NICKY'S AFFLICTION

Inside the MInd of Juvenile Correction
By Ssaint-Jems

Smashwords Edition

Smashwords Edition License Notes
Copyright © 2017 By Ssaint-Jems

All rights reserved. No part of this Publication or its Trademarks: Cinema Book and Still Motion Picture may be reproduced or transmitted in any form or by any means, electronic or mechanical, including photocopy, recording, or any information storage and retrieval system, without permission from the copyright owner: Violations will be Penalized. All characters appearing in this work are fictitious. Any resemblance to real persons, living or dead, was coincidentally created through the pure use of imagination.

Table of Contents

Introduction
Chapter One: Misery
Chapter Two: Deeply Swallowed
Chapter Three: Holy Spirit
Chapter Four: Reflective Ascension
Chapter Five: Malone Hills Academy
Chapter Six: Author/Creator of---the Cinematic Book: The Newest Visual Entertainment of Our Time
ALSO BY SSAINT-JEMS

Introduction

Nicky's Afflicon is the voice of the voices as far as the world streches with adolescent complaint aginst authority. The emotions Nicky Dorsey wails throughout his heart, is a thorough of the bastard ill, juvenile correction can wickedly cause to the free spirit of the careless teenager. His feelings lacks no notice to every detail of the inner parts of confinement , as the underlinig brainpower to refrence the book of the journeling soul with every sketch and strnd about the ideas of pin stripes and slave shakles. He interprets the deepest operation of grief, sadness, horror and anger at the high top of the temples brillaince with a tongue although tied down by the sharpness of barb wires and cell blocks. Nicky Dorsey is the sharpest story teller of his rebellious age-group that is force to give up what is liberally essential to them in their lack of freedom.

Chapter One

Misery

These stars are gifted in their flickering arrangements, a varied richness held to a brunet dome, that I've seen in midnight. I'm immersed in a diversity that brightens my thoughts into an astonishing wonder, about the multiplex of this unique gathering. In this glory filled mania of bodies, dreams of a higher kind is felt in this stellar occasion, while in the midst of this spirited smear from this higher glow that is expressed through the overly packed persons I'm amongst physically. Caught in the deepest daze of this inspirational reflection, I'm removed through the thought of this sky-bound day-dream, that are the mysterious patrons whom inspire the characteristics of my twinkling thoughts.

Any observer can see the saintly abstraction of heaven's reflection in this worldly grapple. Glimpses of a rainbow kind in ghostly float in ascension's rest, contain innumerable spirits mixed in anxious wait, that congregate to see some JUDGE. The eternal sense of my spiritual muse is presently reflected in this impatient bustle, jovially cuddled by strangers in ado commotion. These ever changing orbs in the galaxy of this fertile womb, gives life to one of the many facets in this jurisdiction that are these always entering and leaving court-house officers. In this always doing something stance, advocates for citizens and government are the intellectual forces in this correctional system, armed with mahogany paper, brief cases, thinly contained by a brown lining string that envelopes files of evidence and defense these judicial warriors carry around like shields. Whatever legal war they must battle, they are sharp as the glamor their professional status requires when in the highly regarded world of justice. An intrusive busyness from this defensive character calls on everybody's attention, through the squeaking sole of their shoes that denies the, squealing, clean, surface, floor, the gentle gestures of thoughtful paces. Their ginger-less actions are traded for a frantic fury in their scurrying sprint, with overly packed forearms and hands, that are heavy with files, on top of files, they must work on today, in this excessively charged presentation.

This domain where we all wait, spilling with all walks of life, pleases me with intrigued excitement. The congregation that masks me into my incognito disappearance, makes me a lost riddle in this bustling public. My cleverly covert presence amongst these strangers is gratifying to this condition within me, that bask in this public's crowded exposure, unsuspecting of my, nosy, prowl, about this environment and its inhabitants.

Everyone anxiously awaits their court proceeding to be announce by the Court Officer, his every move watched with a serious praise that glorifies him as significant as a lawyer and judge. Because of the strong anticipation of my, what will happen to me emotion, I cautiously read his, loud, bold, lips, that shouts to this, sitting or standing, awake or sleeping, audience. On a border dotted spread-sheet paper, cases are placed on a deteriorating wall, that shows the torn and worn

aspect of this, filled to its overwhelmed capacity place. Numerically, following a name, a litigant can find their case to be held within the significant area of this court house's commentary mecca.

On these, brown-row, cold-court, benches, children sit in the lap of their mother's, next to a guy reading a daily paper, and those who simply stair themselves into the imaginary world of a spaced-out retreat. All you can do is look and observe to get through these precarious moments while one is in wait. This imaginative play within the thinking self, is all that can sustain me at these questionable moments, my fate already known by those court room barons, whom rich with the authority to dispense the law, that will author my final revelation.

From my lonesome force feel, evoked into an inquisitive query, I ponder about my surrender in this chaos, that is buried by innumerous faces, which makes me chat-less and furtive in my analytical interpretation about this public to myself. I await with colorful nebulas that is this star studded humanity, whom universally blooms, as, all walks of life, which packs the courtroom beyond fire safety capacity. I too am a stranger in these unknown opposites, a nebulous wonder of who I am in these alien ideas. A fascinating encounter with this diverse community is laughable in its discovery of this eclectic society, whom hilariously, constructed in every, uniquely, off-the-wall, artistic-abstraction. And I'm woken to this pleasantly bizarre spectacle, that are these obtrusive people in their overcrowded spill, bringing close to the observer a United Nation's eccentricity, that's in wait for their deliberation.

I could only avoid my doomed existence that may come by neglecting worry for the soothing calm, my naiveness pushes deeply to the recesses where my forgetful oblivion within me resides, which helps me forget why I'm here. My intention amnesia leaves me more interested in what I'll have for lunch or what I'll do when I get home, on this, October, thirty-first, day, razzle by the decorative celebration Halloween is frightfully known for.

Abundantly bright and pristine is the life outside, looking through this window. The scary excitement of Halloween's playful charm is harmless in its child like make believe.

The ever rising outcome that may happen to me, amazingly, is unable to be shaken by the clinching behavior of my scared silence, so I could hear the wispy calls of my sanity through the loudness of this mysterious complaint. My fatigued sickness is so sloppy with adhesion to this weakening force that belittles my nature with crippling fear. I try desperately to push my most likely fate to the back of my oblivious stupidity, hoping that I'll go back home again.

The many times I've stood and sat in this officious domain in this Brooklyn jurisdiction, meant nothing, the Judge sending me home, remanding me into the future for this tedious punishment. The rituals of scanners and buckets are used to secure this heavily protected facility, lines extending about a mile in length down several blocks, keeping lawful subjects waiting in bitter cold.

Finally, I'm called by the court officer, where the highly esteemed stature of his directive personality momentarily befriends me with a welcoming acknowledgement that tells me to step forward. The worthy ideas of his position seems remarkably true through the official patches of his attire and numerous keys that are used to open the many hidden gates in this world, into other dimensions far from this public's watchful eyes. A bold and very loud regard for those whom

will step toward a judicial throne, is made significantly praise-worthy through the association of this awaiting ruler's messenger. The crusty lips of morning, bull-horn, my newly bestowed nobility with a screaming fame that tells me to come forward with a mouth that glorifies my name with numbers. A deep seeded complaint quietly wails in the unseen space of my emotional worries that belies the external presence of my fresh face and clothes that comes alive in the care-less wonderment of this audiences imagination. The meaning of Nicky's, just another joe, existence is pondered with whatever attention. One risen, blurry reflection from this rainbow of life, in its judgmental walk, is briefly in a split-second, displayed, for all to see. My name think-fully simmer on these minds, internally, echoing, NICKY DORSEY.

 The objective omnipotence of this realm's judicial quarrels is freshly resonated in every eventful deliberation that plays in the movie theater of my intuition's stage. Performances cloaked deeply in a harmful theme of affliction expresses savage offenses authored by rapist and murderers that is condemned by a dictator clothe in flannel ebony, and all else, thief and petty in not paying a traffic-ticket occurrence. Juliet and her male opposite, could never comprise the deepest tragic form of poetry the madden eulogy that countless lovers ready to breakup, reveal, for the purpose of their divorce that is heard by a jurist famous for their satirical judgments. So frequent is this lawful revolver within this busied space, briefly occupied by people that surrenders to this scolding tongue, which is the distinctive person you respectfully call, your, Honor.

 The bold and riddle emblem that decorates this ordain facility, is bless by a lady in a gown, that is intricately fashioned onto a circular plaque. The wizard genius of the anonymous sculptor that inspired her cryptic design, blind folded Justice, who's self-taught affection needs no physical eye to see the elegance of her non-judgmental wisdom, while marrying her, to the stability of her faithful hands, a pair of scales that assures Justice will be truthful in its balance due to her libra equality. The helm she hails from upon the Goddess mount of this highest mystique isn't enough to be secured by her feminine acclaim, her protection at ease without slaughter in its protective display at her fair side, ready to jousts any evil that will disturb the equilibrium she must uphold with her ready sword.

 The housing abode of this inner court is baffling in its judiciary prestige, igniting fear and courage in my pleasantly awful interpretations that emanate from my fascinated heart. A costume dictator in human presence comes close to a true honor in the fleshy hoax that enchants this room with its fictitious worldliness in mortal form, which is giving reverence better then this missing divinity it seems.

 The enveloping eloquence of this entire, ornately, interior-decorated, facade, isn't shaded like the, jet-black, sky line I observe during night's starry presentation; instead a endless top to bottom, soothing, but, firm, deep-amber picture that is this, autumn, walnut, finish, gleams with a polished perfection, it seems not even the most adept interior designer could include in its swirling vision, when lost in thought about the effect's of a color's vibratory essence that gives a world its tone to live by. My dreamy indoctrination from this room's unseen spirited counsel gives comfort to my intellectual and shallow-brown wonder, that is grouped by the physical release I commit, as I, sit on a cushy leather chair, that loosens the tension hidden in the silks of my precious soul; which tucks me comfortably, in its, curvaceous, fall-a-sleep, welcome.

The Court Reporter who's typing, fills the quited court room with 'pecks,' and the sound of moving paper enlivens the stiff and dull atmosphere, which are the integral components in object form, that seem to be the only things in its enthusiastic participation, full of, excitement, to be here. The Court Reporter records every word that is spoken: this record will be converted into an official transcript of the trial. The sound of the keyboard is somewhat pleasing to my ears, the conductor lost in her finger tipping talent, showing off her skills to this inner public, occupied by officials, who have around their necks, dangling metal badges with echt numbers in blue, proudly displaying their judicial distinction.

The Judge seated at her bench is elevated above all, whom seems cooled and guarded by a comforted courage full of superiority that is lax with a ridiculous simplicity in its casual power. This aristocrat is dressed in a distinctive black robe, in which their could be no dominate color except this puzzling perception full with wonder and fear, that is, more then good enough to symbolize a representation of Authority. In wait by her side, a dynamic power lax in its sophisticated display, it too oozing something profound, that exudes a gentle quality, and a concern--awe, in its condemning exposure, which is a gavel for such, honorable annihilation, for a master craftsman that wields the knowledge of the law with effortless thought, through the final destruction of her wooded sword. In my immensely still imagination that inerts my ideas about this judiciary master, I reflect on the meaning of her appearance: could it be the elevated tar of this universe, mimicking the infinitely expansive and immeasurable, ALPHA, like authority of this all-powerful space, displaying her omnipotence to those below her mystifying magistrate. She hold's my life in her worldly hands, willing to do as she pleases with it, exerting the simplest authority to sentence me to death. All must surrender, where if this majesty looks up at you, greatness is given to you, through her gleaming eyes.

The distinction for which the Judge assumes is surely felt, reflective of the nighted grace that fills this unsurmountable universe which is color coded by this superiority I'm made to feel down below, in my dwarfed placement. I'm prohibited into an, exciting, bittersweet admiration about her dressy charcoal complexion, as my head is compelled to keep looking above.

This un-talked trickery that is this tedious preparation darken my imagination with reverence and ill wonder about this breasted night in a gown, which has a better glow then the plain bankruptcy of an ordinary day's illumination. This forcefully woke-to-power, is a melanize vibrancy in the deepest shade, in accord to a superordinate nature too achromatic in its nebulous quality to understand. It seems I'm more alive then waking faces unhappy by the boring calm of dawn's ritual. My slightly robust, wide-eyed attention about me is due to my unprotected back to the abyss of this wall-less confrontation that would push me off the edge of this dangerous grace, which litters my thinking with a explorative language that inspires my beautiful ideas with the nature of negro. It seems I've imaginatively learned of midnight's essence which paste stars to twinkle, for which a Judge comes close to emulating, but short in its interpretation, no matter how obviously splendid is this re-placement.

Indeed she is one to coddle with unwavering favor, an appeasement to be in the good with this worldly Shiva so her judgment can be in favor of you. At my current stage, as a deprived teen without riches and connections, that mobsters and politicians are insured by, which is a

cheating bribe or extortion that could persuade this honor's final judgment to guarantee clemency in my case. Hopefully, the sad story of my calling so far in this life, would fill sympathy in the heart of my current maker that has full control of my life from this deliberating point.

 Endlessly, in a, long, ruffled, black-satin-robe, she sits in her wallowing comfort reading documents, not even once gracing me with a morsel of dignity with a simple glance. The creepy humbleness of her mousy calm defies silence at every anchored peep of her nosy dip, that, close-in, her eyes to my sad and gruesome story, she doesn't care enough about, to soaked my text with tear-drops that would immortalize the death of my most precious character.

 Her prominence gives an impenetrable hubris to her unwavering honor she styles quietly in her self-absorbed higher ranking, that has eyes only for her own acknowledgment. She's ginger in her egotistical discovery to the unknown portions of her lost identity, a self-righteous action that is clearly seen, which give illusion to the study of my case that keeps her away from her, own, bravado's, self-applauding narcism. Her bifocals are as sturdy as the firmness of her ghastly persona that cannot deny this highness her center stage in this judicial palace which sharply mirrors with a singular emphasis her vain significance. I'm dumbed into a cloudy apprehension by the gentleness of her niggling insight at every turn of the page that has the printed information about my case she study's painstakingly, she seeming more involved in every thought about the future of her leisurely escape into her regal world that awaits this well-pampered elitist. Not once I'm giving a visual sip from a neglected glance her wondering conceit fuels within this shallow individualism, which is this visionary drop from this dictator's celebrity that would satisfy me with a scintilla of her famous dignity.

 I'm envious of her rooted arrogance in the self honoring position her selfishness relishes in, enviously taunted by the silence of her all too calm, fierce and confidant posture. I'm unaddressed by the convivial foray amongst her self-loafing acceptance to everything that is akin to her conceited personality which is criminalize by her ego's lust to be alone. I wish the good world could see her neglecting ways that leaves me lonely in self debate during this rude disconnect, due to the orientation she wants to do for herself, leaving me in my, intellectually infuriated wait that leaves my mind engorged with a heavy gather of thinking burgundy, which fattens the arteries and veins of my full grown imaginary ideas.

 I'm troubled with innumerable fragments that overshadows my observational reverence, about this famous leader. The only active portion of my swollen speculation are the cynical assumptions from my hearty ambivalence to torment my elevated rival that give judgment to my pathetic life, better then I can, in my self-defense, only for the ears of my imaginary counsel I fantasy in my head.

 I'm unfairly routine by her forceful normalcy she plains me into. I'm made subject to an inexcusable abandonment that makes me obviously unknown, even in her, in-depth duty, immersed in every page of my scripted deliberation. In denial of my fleshy making, she attempts to gain my spirited meaning through scattered notes, that are only these few harassing pieces, beset by the stillness of her molesting fingers, which could never give truth to the story of a civilian's demise, made even more coarse at this, undignified, mistreatment.

I wish my current worst could be given angelic gestures a coddling mother caresses a newborn with, with the most cuddling nurture, due to my mother-less anguish that is furthered in this agonizing frustration.

The perverted inquisitor to the orgy of my prolific wordiness, is mutely excited by the nature of my case, she held by a searching explanation to my reason's attempted expression. She now seems earnestly studied with my case, without the selfish ignorance of her self-love, she inclusively deciphering every cryptic design of my soul's, severely stained adhesion to life's suffering, which is typed on the fallacious tablet she falsely holds, that was authored by policing idiots. Her blase and yet enthused study wavers into an unreadable body language that seems more over, into a merciless survey to condemn my attempted obligation, she'll spite with her correctional gavel.

She seems smitten in her refusal to comply to the unity I seek from the jolly distinction of her sophisticated supremacy. The unkind enormity of her distinguished cruel shows off in her phony smile, a luckiness that's yet to happy me into freedom that I hope she'll adjourn this proceeding for, in the sake of my escaping liberalism. I never encountered a person so fulfilled with satisfaction, a professionalism that suppresses the meaning of life's freedom, I could never abide by in my wild expeditions that perfects my delinquent adolescence with uncertainty.

The fallacy of her careerist honor, just to be in a high paying job, shows the money hungry agenda of her well paid status. Although her bank coffin is cusp with riches, the emptiness of my earthly exemption from the thirsty pride of this business women's ilk, brings this rolling stone to many thoughts that ascend me into the enclave of a costless heaven. The aristocrat elite that supervises this so called, In God We Trust, law, could never be perfect in their dramatic emulation, that shows a fake imposter that is way too gaudy in her desperate desire to show she's endowed with this jurist ranking.

I'm disinclined by the arrogant favor of her grinning gestures that seek appeal only for her ego's nurture, because of the celebrity, it seems she's been told she is, in this star-struck stair, I inferred her with, which fuels her conceit for more eying fame. The introverted admiration of her resplendent lost that only fathom herself, in a overly well-groomed manner, displays, every sparkle of her posing posture which model her obsessive fame.

The dashing fold of her robe's collar is an indication of the fine tailor that caters to her dapper fashion, a simple stitch of thread that is more expensive then my worldly poverty. She brandishes her confidence with the curling stance of her raised eye-brow, along with the chest portion of her bust, that shows the peered abundance of her, buxom, female, nature, that is her bulging breast, held inside the darken veil of her glimmering robe, which is a picture perfect ceremony that show's her very proud snob. For a moment she seems reduce into something less superior, shamed by my deepen study of every action she proudly exudes, that is penetrated by my heavy eyes which illuminate these ideas about her, in every nook and cranny of my depicting criticism.

I'm un-compelled by the previous dominance of the ideas that swelled my head with contemplation about the director of this court, I can't help but to detract from in my worn out study, which compels me to something else that is as fierce with greatness in its life-less stance.

This mecca for people to be judged by the person seated at this bench occupies a column that is, awe-inspiring, in its, smooth, wooded, elegance. My imagination is seedy in its lace, as to where it derived from? Its once earthy unadulterated form has a cognac-mahogany, honey like, brown layering erection, with swirling shadows of twirling lines, that compels you to its highly attractive nature which display's the reflection of me on the gleaming bench; and the past events that once stood before it. This opulence is surely felt, distinctive furniture being the integral part to the ostentatiousness of this authoritative abode.

The bench itself has more dignity then the Judge in its wooded excellence, it representing the closes thing to truth in this erroneous justice I stand in, that is more corporate then actually being about the law. The bench in my imaginative condition seem to be more powerful in its, tawny, acorn, amber grace, triumphant over man's worldly laws. This, the object of this talk-less bench's origins evoke worlds within the flesh of my thinking head, where the: maple syrup, french speaking, snowy-cabin, rooftop, mountains of canada's vast timberland, is possibly where such beauty descended from, that is the bench before me; the dresden butternut hue was once risen from deep-amber-almond soils that is nature's toasted hazels in mineral form, its soul telling me of its dirtily essence. The thought of Nova Scotia elicits a sense of, how far and wide this wooded bench once possibly stood tall. This pleasant vastness made of this forest decoration grows in its isolated abundance, that gives comfort to me at this sensitive time of waiting doom. This envisioned destination of nature's essence in its completely pure isolation, allows me to escape while in the captivity of this condemning Queens' bitter hold, which gives me slight reprieve.

From a snowy existence to a heated climate, I think of a tropical island that possesses a creole speaking culture of men working in straw hats in the hills of Haiti, who I see vividly chopping trees with axes and machete's. The tears of pure oak spills from the sweet innards of exotic trees which yields a flavorful form of aromatic coffee that's rear in its enchanting taste: the cafe au lait of dun fallow in this autumn leaf complexion, is buff, in its, camel, sensation, derived from the mystical mountains of Haiti.

In my exploration I'm lost in deep wonder ... entering the far spacial distance of Washington state. Ancient barks that made this bench I imagine is cried for; a tribal dance was done around a missing friend uprooted from its precious soil.... If this isn't enough to distract me, the "God we trust" sign propels my thoughts into some condemning eternity, never to come back, instilling fear instead of hope in my adolescent heart.

I'm talented with a self possessive wisdom that is ever blooming in its search to gain sight into what commands my deepest attention, but, at this questionable time I'm more blurred then a lost ship in choppy seas that is disastrously decorated with a foggy blindness, due to the ill atmosphere that is the language I cannot understand.

My court appointed lawyer cruises amongst sharky predators that penetrate his debate with attack, hoping to provide a adolescent meal to a seated wail that will swallow me whole. He engages in courtroom vernacular my ears can't comprehend, language specific to this world, which is foreign to me, too esoteric for my common intelligence. The vernacular of this conversing engagement is nothing but empty speeches of sound that annoys my bored senses, a gibberish suffocation of blab that presses me with a, weird, left-out, stupidity, giving funny shape and emotion to the confuse look about myself, amongst a ever chattering counsel in deliberation. The immensity of their intellect's stamina has surpass eternity's limitless existence, a workout overly intense in its overdrawn courtship from legal aid to a Judge that needs to be wooed over. These feuding tongues began in seconds that became minutes into strewn out hours of wondering wait?

I'm now confuse about his faith to save me, I seeing this advocate as my freeing hero, something that appears in his intention on these floors he pases, his legs heavy with words and more words akin to his profession, that may talk this official public to grant my return back to my prison-less days. The defensive messenger heatedly engages in the best refute he could lawfully shoulder it seems, in a judicial fight for a litigant, that couldn't buy the very strong enthusiasm of his strongest rebuttal.

On the opposing side that is willed with anger to dispose me forever, it seems their is a vengeance to deeply degrade me into the savage status for which I want to stay out of. I'm thoroughly battered by the negative reverberation that shapes my heart inward with stopping fear, that are eager gestures in this greedy abandonment for me to be displayed in the underworld they'll never come to, except through a narrative documentation that will tell my every movement inside the walls of juvenile correction.

My emotions are so fused with indifference to the correctional entrapment that will shelter me into thieving bricks, which are these, cold, psychological knuckles that pounce the sensitive kernel of my wises emotions. Even in this weeping frustration my civil is maintain while in my innocuous protest. A calm about me resides deeply in the denying stupidity of my naive soul that tames me into a descent kindness which is all too ready to become rage, amidst the uncivil behavior, this Judge's world inflicts with awful comfort.

I'm brought forward by a erroneous justice that questions my life, which is a fooling illusion of this representation, acted out, on the stage of this theatrical condemnation that is weighty with cancellation to my freedom.

Suddenly, all is said and done, and I'm being uprooted from the position of this free dwelling, a apprehension of arrest, me, frightfully escorted to some back room, lead into the deception of the wall's beautified hollow, which is a wall that is an actual door, a secret passage way for people to be ushered into captivity.

The inhabitants within this scene is so tranquil in their uninterested casualty to this, severely, uneasy development that must allow this confiscation to take its place. My magistrate's lifeless unsympathetic face has no remorse it seems for my tearfully bereaved existence. The courting front for the justice I'm made to believe I had, didn't mean anything. In the false

eagerness to halter a judge's decision to harbor my life that is this supposed legal-aid, was really a cohort with the one dressed in noir that is seated at the top. The Judge simply condemned me to my ill awaited fate away from the normalcy of life. This worldly Empress, effortlessly banish me into the cold mystery of my awaiting life to come. In the furious action to apprehend me, I ask, what is going on, and the room is without a response to my sorry inquiries. I sorrowfully, repeat over and over, for which only eyes and silence answers this neglected degenerate, as my greatest sadness limps in its damned linger, unfortunately forward, into the brittle host that is apart of the troubling map of my destiny I must journey through, according to a spirited law a deity authored specifically for me in this lessoned challenge.

I'm dogged by unresponsive howls that is unbelievably cruel with laughter in this intensely rude cruelty that are muted lips to me, but jolly with colleagues in talk of what they'll have for dinner tonight.

Charlatan's they are, whom nothing without honesty to their doctrine they evade better then heathens without thought to a higher gospel, they fall short to follow then those whom they think their trying to save. If they only knew, I'll become the telling narrator through the storied savior of my deeply notable documentation, echt on the stabbed tablet of my heart. Interpreted as death in their omitting actions, I will, somehow attempt to illuminate this daunting darkness, with the frail heart of my novice feelings, that may gather the grieving substance of this correctional nature, figured by these god-less makers seated in a flaming bench and court room.

My lawyer's loyalty held to a jurisdiction that has none for my likeness in this alienating offense. The stuttering disbelief of my idiocy is given a language I've momentarily mastered with a handful of gestures that tells this atrocious public, what I attempt, sorrowfully, to say. My life is starting to enter a abominable dejection that will eventually vacuum me into a meaningless existence I won't be thought of. My stupidity seems true for how I'm already extinct from the visionary exclusion of these inhumane thoughts that have no room to enable the freeing idea for my departure back home, which is calmed by a darling politeness I'm still yet to be welcomed by. I'm now property of New York State. I'm Gone, tightly held by the Judge's court room GORILLA'S. I'm swept into my next life....!?

... This willing neglect is so fierce in its abandonment. This drive of nothing is only to sit and gaze, so the, shall come to pass of this moment, shall take its removing place, that is this wrong uprooting my life into an unknown elsewhere?

Grim cold, emotionless cheeks, stare, unappealingly, into my sorry eyes, with a stern, selfish anticipation for what these lawless animals will eat later. Prim and prissy in their happy go lucky suits, they presume all is well in this deceitful world, very happy with themselves.

This boasting condition, is that, a well-being so comfortable without a micron of hurt for my neglected kind. They stand still in the moments of a wrongfully convicted, Philosophic-prince, who's actions were more honest then this Judge's worldly wisdom!

My hurt is vividly alive in these non-sorrowful eyes, in watch of this ushered into no where, youth, slave. These hurtful pulses of reflective thought about such brazen moments, squeezes my

soul into some sort of death, I never felt before in my still growing life. What hurts, is the blasphemes ease in the effortless gestures in the form of pen and paper, my life is horrifically scribed.

Not even a plea for me, my kind without innocence to shake the hearts in this judicial auction, who's conscience are without reception to show loving mercy to my juvenile ilk. This sympathy I seek is this total opposite, they, enthused to push me into this torrent fire.

More evil is the deep seeded will of quotas by some municipal government, who's greed is feed by federal dollars in the millions to keep me. These agendas are so many, without any defensive force to keep me out, my life is captively giving away, bartered for a state's financial growth into correctional worlds, who's colorful shades of unknown riches, fill to the cusp with gold.

My dignity only came once, briefly amongst a glimmering bench, that spoke of my radiant brilliance, at each gloss, that was a towering column in walnut finish. My ennobled light before such throne was so tall in its opulent promise to give me justice in its reflective sway, protected by, my gown wearing girlfriend in bronze, a golden pendulum who's untouched balance that seemed beyond the reach of these corrupt rulers, I thought would keep my well-being in harmonious poise, draping myself as victor in the bust of this goddess's cleavage.

Pink bells and sweet curses sing into violent skirts, exposing, a, plump, panty-waist, theme, I jealously learned of while on top this mystic secret her brightest moon could reveal.

Still unannounced to the truest source of my flirtation she knowingly authored by the breasted bliss of her mastered trance as this highest romantic I'm learning from. I'm bullied by the femininity she quiets me into, with the pink-toe basics thumbed by the fragile-ness that helps a madame choke on the rosy lyrics of my lower thoughts where spirits passionately escape into a hidden core of her more creative tone, dress with feminism's gloriously slick splendor.

A wide and long admiration that is authored from me, is evoked by the pierce elegance her feminism authoritatively fashions with high-heal problems my envy knows isn't exclusively mine, due to her show to this needy world that wants her to be loyal to this masculine audience. This statuesque girl is talented with a un-shallow kindness, which is all too inclusive to every type manned, by a variety only nature could eclectically scheme.

In this fairy-tale, full of finger polished illusions, she's, no lover of mine secretively alone in my strongest cradle, which is but more then one, she must gracefully attend, with the jolly and truly cute attitude that makes my murderous humanity bright with chest and derriere ideas of civility.

A bogus deliberation gave lie to my promised rescue that never was in this illusion driven existence in the house of this misrepresented libra, a love crazy faithfulness that betters this rejection, that a stubborn wife is stuck to, which fuels me at this sadistic time, wishing her companion the best in this thorough devotion, still held high, as an, un-dieing, allegory, that's, lady Justice....

My forgotten celebrity was not to glorify my performance in deliberation about my artistic talents in thought, but rotted with wrong in every whispered speech, between, legal-aid and ruffled dictator, that critiqued my life, while I, in my shivering worry was stilled in the deepest frost before my shattering judgment....

This condition I'm in, as of now, is a glimpse into the harsh reality, for which I'll begin to live. This tremendously drowning grief, squeezing the personal parts of my most delicate insides, doesn't want to let up! The enormously, imposing, forceful will, of these courtroom GIANTS, thoroughly comb my pockets with their BEASTLY hands. The desperate feeling of my irate nature that wants to come out, is weaken by the heaviness of this corpulent complaint, defeated by the disbelief of the circumstance I'm in.

This increasing blight slowly builds in me, inwardly choked by fear, that's working its way outwardly to untamed sobs in this breathless worry; I'm without pussy cat tears, but my fright is all over me, these courtroom bull dogs able to smell my cat piss if they were a hundred miles away. This puny frame of Nicky Dorsey is searched harshly without remorse to my unfair conviction. These emotionless-manic-gorillas are employed to do all the dirty work, without queasiness amongst this lamenting face. These beastly bullies comb over and over my empty pockets.

The mandatory ritual of this search is not only done for the basis of protection for those that may be around me, but this physically saving investigation could thwart, the now, strong possibility of my evading suicide; puncturing the life ending carotid artery, veining from my inner circulatory system, coiling upwards around my neck, finishing my pumping heart's flow, that supports Nicky's aliveness, in this hateful hold. Easily I could eradicate me from this monstrosity, where the jaggedly sharp knife I would have used to uproot me, would have menacingly spilled the ruby preciousness of my runny blood onto the backroom of this spotless floor.

The grimly performance through the blatant menace of a butt-cough has to be done by me. These homoerotic officers blasphemes yap's tell me to pull down my pants!. In the, forever-remembering, making, are these eyes, permanently recording the ass cheeks of my butt. How could such exposure be permitted by these butchering retinas that will scope the inner crackling of my rectum. These beast indeed are wicked in their perverted execution. Indeed the council that sent me to this doom could never be pardon for yielding this blight expose. These MUSCLE bound delegates are accomplices in their gender-bender rules, they're enjoying it seems, in their unmasking secret, that will show no victoria their in search for.

If I could reach out from this revoltingly depressive torment, that heavy's my entire existence, I would boldly squeeze the internal system of my intestinal track to disgustingly spoil these watching noses, with a foul toxic effluvium, that is more rottenly toxic then any oil spill, spoiling the most pristine richness of any ideal; blue water, swan swimming, pink-daffodil, lake. My only weaponry is this gaseous green flaming fart to stop the hearts of these rapist that examine my back side....!

 Unable to refuse such, skankish, gesture, I flank my booty for these guards, who supposedly are just doing their fecal job. The jittery nervousness of my molesting finger tips are brave in their fruity actions, an un-thrilled gesture so unsuspecting by the confrontation of this pornographic menace I could have never prepared for in a billion lifetimes. My naked fright tingles my arms with a contorted apprehension, a fidgeting clumsiness with the straps of my slippery brief, me reluctantly in my severely shamed, slowness, gliding my underwear off my boney hips. The dishonor of my showy eroticism elicits these, boy, loving deviants into a repulsive excitement, nose's fouled by the notorious scent of the funky skid-marks I've artistically dressed into parallel patterns for my hated admirers to inhale and see. The printed flair of my buttocks, suede, this cotton canvas with heavy textures that resembles an oil-painting, amber, color-scheme, showing off my unsanitary Rembrandt ability, I aptly title, ' The lining sewer of my stooly suffering ' their foul noses cannot deny as absolutely retarded, in its, creatively, shocking, odor.

 I have no loyalty to my nature's masculinity for how I've betrayed the thorough meaning of my dangling kind, where the nature of my organ attach itself between my thighs in disgust to this smutty presentation it doesn't understand, I must commit behind bars. My inwardly coil essence wants me to return back the ego my deity gave perfected thought as Adam in this eve-vasive correction that questions my sex into this brutal mystery I'm punishingly confused by, me, having to cock-over, while gripping my knickers for this un-arousing display.

 Amazingly lost ... the bewildered entrapment that plays a chaotic chemistry in the embarrassed yonder of my shook soul, simmers the most sacred part of me with a hype complexity that annihilates my calm into this intense disparity. My mind holds onto the thinnest grip sanity meagerly offers. My beaten exclusion from the reality of my well-being's common sense is given something demented, made of a psychopathic silliness that is the deranged rumination of my laughter that shows the creepy disbelief of my neurotic suffer. I've become a weirdo incomplete by the mixture of this deranged dis-ease, a lunacy I'm held to, between this savage dawn and obliterating dusk, I'm ever emotional in, with a sociopath silence I attempt to un-puzzle with my cockamamie judgment.

 Still berated by my whore-ified performance, I'm led upstairs after displaying my fleshy, deep-brown, chocolate, butt, for the burly courtroom bastards. A feeling of some awkward sort antagonizes me unbeknownst with mixing shame, so tensed by the pornographic cause that this world is delighted by. Sexually disturbing was my action, courtesy of the criminality of this environment's prerequisite that I've faced in disgust. I'm still yet to encounter the full-blown exposure of this world's make up, for which I wonder, what next I might have to do in, triple-XXX, disgrace. The stench of this misery suffocates me into an unclear annihilation that stiffens my lungs with the deepest worry I never felt before in my life, a evasive force so reckless in its disappearance that is yet to show the full extinct of its locked-up intensity.The cleverly concealed door that I assume was the elongated, four wall, pine, finish--facade, I imaginatively marveled at, was actually a hidden door that opens from the inside, a wooded threshold that leads to another buried door, which then bring's you upstairs, where, I'm now, with many youth like me, who are sitting in a heavily felt form of profound distress; they too, once upon a time in a court room was subjected to the gruesome reality of being stolen by the court system, orchestrated by all those people in that phony justice, who silently sat by and watch us leave. Our

delinquent kinship brings us together, whom fought gallantly against such indestructible scheme that is backed by persons whom from a higher station in life, we're unable to topple while in this bottom class, maimed by the many facets of our poverty. We're homogeneous in a spectacular making I'm unaware of, life's occurrences having in them difficult issues that leads to a good ending, which gives purpose to every suffering we're made to go through, that's not in vain.

My groaning soul is not the only one caught in this, searing, torch, like, flame. The psychological drama unfolding in me is similarly felt by those, who I see, seated, now. Surprisingly, I thought I had to be the only one unique to this capture. A weird comfort from my comrades slightly soothes me, due to this integration, where, secretively, youth like me are apprehended. I forget about those scuzzballs who searched my entire anatomy, seeing the fleshy exposure of my pubescent scrotum, a roughing up that these courtroom gorilla beast brutally finalized, by pushing me into my new dreary destination, for the further advancement into hades incinerating torment, that elephant heavily on my mind and heart.

I'm in a area that is patrolled by two plain clothe officers. Their manner's seem more chummy then the aggressive state that this way too coarse environment requires one to exist by. This secretively closed elevated boxed area is complete with a room with protecting fiberglass, where next to it, the clear silence of a forgotten tissue, left in its snooty bawl--in used up twist, tells me about its relation to my failure to come, my decoding mind then seeing, chairs and a table, for a lawyer and litigant, which at this time, is occupied by the room's logical inhabitants.

The lawyer's brief case seem to exude a form of freedom I so desire, a imaginary wellness that completes my thoughts with awesome luxury I see myself lavishing in. The precise particulars of the gold encrusted feature that are buckles and locks gives royalty to my shimmering crown that I hold above the ideas of my captured head. The free man that is the lawyer, is perfect with such fame I could only think of, for which he participates in, every day of his well off life, he too lost in the dainty decorations the lords of materialism shower his expensive life with, more concerned about the re-entrance into his wealthy world.

How can I forget the heart felt banquet of a family's earnest embrace, especially from a lady I wish to have in my panty-less detachment, a touch-less grasp of a women's hips, my fingers reduce to the self pleasuring thought about the professional adult star I see inwardly piercing, a horizontally weeping moon. The imaginary intensity of my sexed up vision could never be vividly fulfilled by the actuality of intercourse's insertion, for which the tall prong of my lower wisdom needs to force itself into venus, with only the intentions to express my stretchy glee, to reach my highest pinnacle that shows the spirits, I'll give life to, through a molten womb.

The severely circumcised devastation of this fortunate baboon is given a feast that feeds the deepest parts of a man's sensual indulgence, that is the thickness of his lady's back, which excludes me into trouble, bothered by the false elation I can't truly complete as the perverted jerk-off that I am in my frustration. I envy the completed satisfaction of his attach nature to his loyal wife, that orally plunk with the cockcrow of every sunrise, the pushy tool of his lower excitement, to ensure he'll bring home the well paid dollars. Wrinkle sheets worn by the active part of a baby making carnal, that enters the pleasantness of sleep, show's itself in the moist aura of this, all-is-well, lothario.

The expose flesh of her brightest nature exudes the pinkest pleasure I'll ever honor. I'm held between both heaven and hell, comforted by the dripping rapture of her snug stomach, for which my joy must escape in its eventual departure in my leaving bliss.

How is it I'm possessively stolen by the idolization about the characteristics of her talented sexuality. In my belly folding observational lost, I've gaze with the deepest marvel, every delicate bone and gently veined muscle that is feminize by her darling posture.

The well max aggravation of my un-dieing worship seems passionately continuous in its thorough stamina. My deepest senses I understand as normal is this happily distraught case that study's the very last drop of this questioning glory that is above her possessive fame, my penetrating thoughts are emotionally heavy by. I'm thoroughly grooved by the soften tremble of her excellent suffocation that could pleasure me into my permanent demise.

My pleasantly grieving emptiness fuels the piercing notions of my nipple-less suckle. The whirling irony of this elusive love, hates me into this battered joy. Every elated torment is just, and my fulfilled glee seems to be a broken crush that satisfy's my thump with fire drench norm. Once in my heartfelt past, I shared the blazing encounter that peered me with the reflection of such panty-waist dictator that stood, before me, toe to toe, in mirthful misery. I'm unable to reunite with the flirty gasp of her minted whispers that brought me close to the lore of this ever missing master. In my dreamy ascension, I see the unity to come through my highest elevation....

Declined from the peeping vision of my horny lust, I become celibate with the world that has no room for such sexually inclined debacle, as I watch, without a spirit's drop from this deviant mind that is now sexually calmed down. I now, in my full blown attention interpret the gathering of a lawyer, and the delinquent companion, that is attentively listen to, by an eye-balling legal aid. The juvenile advocate enters the ominous tale of the litigant's explanation as to why he was carrying a gun, in the stroller of his child's baby pamper compartment. In this observational flux I see something enter him that enlivens him with a frighten insight that causes his emotions to bloom with sadness, a tragedy so worn thoroughly onto our adolescent department that are the defunct tragic features from our life's dwelling, that now dresses his soul.

The distressed air in here is filled with an anguish that fills every capacity of our over blown lungs. The gloomy condition of this facility harbors the criminals who are merely children in this childish eye's of mine. We lurk in these correctional shadows that prevent the clear vision of our story to be told, even by the authoring assailant, who too, is daze into an unintelligible expression about these bastard moments that make emotional roller coasters out of our jumpy souls. The blurry condition I attempt to portray in this obscure text is thick with, fear and anger, sorrow and pity, which is dangerous to our existence that's accompanied by a koo-koo retardation that silences us into lost; which could reveal the deletion we seek to evade this subtle suffering. The ghoulish mind that conceived the punishing details of this capture are so true with deception's talent that plays to the imperceptible parts of our deeply offended soul, which makes for the psychotic quarrel we express in our schizophrenic rage.

The slighted buffoonery of this deep making I'm held to by the obesity of this destructive environment, sits comfortably on my puzzled reflection, causing the rioting mis-intelligence I attempt to construct with my bravest wits that's frazzled with disbelief. Its as if I've become every body else's emotions instructing myself to express it as my strange and grieving reality, that tells the lamentation of myself and this greater whole. My illusional cause is bright with a disturbed enlightenment that makes clever my insanity through the cynical language of my heightened emotions, taught by the unseen scripted patterns of this social aura that feeds every heart beat of my thinking into a compulsive inspiration I'm anxiously addicted to. How could I be so sensitive to every breathe from this mouthy gossip that savagely reckons the slightest whim of my idling thoughts, infested with wrong, I perceive to be only about my ego; the weird profile of my self-study exudes a crazy creativity through every heartfelt emotion that is ejected from my foul interior, onto my personal documentation that wickedly analyze this world.

How could I ever be well during the intended passage of my life's fate, where a well versed Intelligent-Designer foretold my every scorn and worry that isn't at all in my eventual victories in overcoming mortality's mere challenges. Although still brand-new in life only teenage with slight wisdom, I already studied the esoteric happenings of existence, that all things will eventually become better, when at the most disastrous edge of calamity and abject suffering. At the points of this strong indifference a other-worldly delivery seems to cherish the soul angelic again in its restorative savior at times acted out through people and the things of the world that makes man and women-kind happy; in my philosophical observation, I've watched this in people whom were terribly ill with intense trouble, which then turned suddenly optimistic. During the entire calling of this harsh drama that themes us children of tragedy, I feel the silenced response within the unseen level of the spirited core, that is covert in its disability we sadly hold inside. I furtively glance at souls whom glimpse secretively back at the advance leader who is capable of telling, what they can't, but sharply feel. What I yell from my thinking belly into the spiny song of this cruel and paranoid sonnet, sounds better then any person I've thus far encountered, whom lack the lyrical talent to punishingly draw the flaws of this teenage zoo.

Their virginal stupidity is so bizarre in its observation to this new arrival, that some how, has occupied the podium, that is, at the center stage of this room. The rudeness of their inquisitive stairs are far from innocent in its welcome that gives the awkward feeling about me in this showy irritation. I'm taunted by an expectancy they want me to be, that I'm already am, in this convergence that immerse me, deeply into the life of a criminal's placement, a sign of an offense in its previous making that lay the path to this odyssey, I now tread with shameful and nervous insult, by the iris of this ever watching vision that come from these boys.

I never journeyed through this form of misery that's so foul in its subtlety, which plays through the calmness of my apparently eased heart, with an intelligible turmoil that spells every meaning of the menace that sulks me into this compulsive dysfunction, my soul gives bitter knowledge to.

My presence pierces their nosy intuition's with fictitious assumptions that fascinates their gossip with the worst wonder, which is hyped with a manic perplexity, as to the meaning of my calling that got me here. Their in search of some acknowledgment that can validate the mystery they self-generate in the thinking tabloid of their obtrusive dialects that is so ugly-fied with

wrong, they want me to correct, as to who I am, and what got me here; while interpreting this current affliction, they want me to define in my inner journal what will eventually reach the curious world that wonders about the life and times of boy prison. I never been willed with this quited discipline that holds me to a chat-less investigation within me, a silence so earsplitting in its denial to polite gestures of welcome I abuse with rude authority in this cold-shoulder, muzzle.

The silenced sword I wield in my introverted selfishness protects a ego from judgment a human's distress can critique, eradicating the sleeve foundation where my ego resides. It seems lm better posses by this riddled tragedy then the physical presence that shows my obviously psychosomatic form.

The absent-minded fallibility of my incognizant youth had no politeness to respect the law, instead I claimed freedom as a tool to penetrate the whore pleasure bliss yields in a law-less exploitation of free will, I don't have in this pressing encounter that tells me to take my life. Countless idealizations about my disappearance stinkingly perfumes me particularly with the flirty invitation to death's withdrawal, like the unseen sense that gives me my disoriented hysteria.

As well as their possessive focus is imaginatively seen in the mirror of their thoughts that glorifies me as their messenger, I too am sharpen by the mind's eye of my presence that makes alert my malaise description about myself and current realm that feeds the teaching of this esoteric adversity. At every toxic cusp I'm ready to spill out of, that I actively participate in through the doorway of my emotional fascination, enlivens me with a delirium that seems a perfect placement at this time of my soul searching life. Irony's perfection, expresses itself backward in its forward truth, no advance mortal can evade, except through its blessed tricks, and puzzling mysterious, clever enough for a smiling deity who see's no deep ill in my world's harsh suffering.

The abundant mixture of these apprehended souls wait in ethers that is textured with the jazziest blue's my lippy verse has to master, in order to fully recite this obscure calling I'm yet to clarify. If not already expressed, a sad case of the deepest regret we wish to exclaim is very thorough in our effete actions: We're hopelessly sorry in every way imaginable for what we've done in the past....!

The mental reprieve we experience in our reflective escape deepens the mystery of our fears, that some how consult us about the challenges we may face in this correctional purgatory. The overly hyped stereotypes of our action packed ideas yields a teary eyed fear that falls downward in their pitying cast, like baby's whom need a parent to dry their balling eyes; little girls are more strong, when in a case of disparity, these ball-less dudes succumb to. Their weeping grief is so intense in its abundance, tears could fill the basin of the Atlantic Ocean with soul-water, where the earthly bowl that gathers this complete sorry's condition has past the cusp that catches incessant tears, which require the Indian and Pacific to store sorrow's non-stop crying. You should see how their eyes are driven deeply into a zombie like stillness, hypnotized by the real encounters that takes root in their ill fated visions. A deep psychosis of suffering that majors itself within, that doesn't only pillage the kernel of their aggravated thinking, but another form of distress reminds us through dangling shackles, what other ailments that is integral to this world

that are waiting to come into our lives, in this visibly physical menace. The bad-music of clamoring shackles adds grief to the deepest embrace of our rhythm-less core, where the cold feeling that is yielded when a great form of sin is committed, turns a once lucid soul into stone and terror. Correctional bracelets seem ready with an all too pleased lust to suck our innocence into agony's oblivion, the conveying entrapment for wrist and ankles that will bring us to the deepest parts of our harboring imprisonment.

 We obliterate our selves into a homicidal practice we exercise through thought, a frenzied silence so deep in its withdrawal, which weakens the body into moments of sleep. Our pause is so fruitless in its dream-less search, we wish could turn our freaky reality into a freeing escape. The omnipresent hoody's that adorn our hoodlum heads blankets us into a state of slight reprieve, from the excessive force of the air-conditioner that give the cryogenic frost of this icy development that we attempt to chisel our way out of, into freedom, in this clothy comfort that preserves our domes.

 Our daze is not just from the incredible onslaught of this waring attack from the disciplinary, criminalization of this stealthy organization, but the force that keeps these fidgeting heads, bopping back and forth with wide eyed alert, anxiously waiting for what is next to enter our stricken lives. An awakening seems to be taking place that make these souls emerge from their insecure cocoons, re-emerging in this offensively stink malodorous capture, where the scent of this environment holds in its nostril's the bleak intelligence we inhale as fear, at every breathe through the nose's senses; a obsessive world that punishes us through many sensations to fully orchestrate the calling of the barb-wire evil we'll be subject to.

 The sensitive audibility of sound brings with it the heroic infestations that take root in our eavesdropping ears, hoping for a fairy-tale passage from this incarcerated chapter by a autocrat author that judged us into this condition. The telephone is all too bright in its audible reflection that plays visions of this Honor, whom on the other line that can grant a pardon that will allow our freedom to be real with reality's release. We never seemed so desperate in our lives before, in hope for some superwoman like character to bulldoze us out this cave; we're more dependent then kicking baby's in a night's wail, by the well breasted character whom I knew I'll need eventually.

 At these needy moments our self-sabotage, is in, not given fathom to some guardian that would rescue us into calming streams on these wings of freedom, which would loosen the tension that tighten our souls into this strongest arrest. The sleepy evasion we hope could elude this apprehension could never silence the loudness of this thoroughly guarded society. The occasional lust of clangoring shackles is rude to the split seconds of silence that is overwhelmed by the iron songs that plays its fate with reminder to our bitter life that is waiting. Rusty gates participate in the orgy-fied spectacle, as ghastly sounds that play the tunes of this world's worst excitement, which is this rusty fortress that crashes us into its dirty confinement. I've almost forgot the well dress persons whom in and out in their flawless exit, abandoning, this holding facility, where, their leave is one that will go back home to a reception of love and kisses, we may never find in this life, even in our worst cry out, for such harmonious comfort.

We are descendants of many shades mix without our true culture in this blurred amalgamation, broken into this singular distinction that makes for our newly intertwined family we tentatively call our juvenile community. Our partnership is criminal-less without offense in this stymied togetherness, removed from a public we couldn't master with the act of civil we ignored with broken promises, better then a addictive person in need of a last fix, where, in our case, crime was the obsessional greed. This is something like detox for sure, where our purge has begun early in our criminal withdrawal we commit, bit by bit, with the seconds that move out the notions of crime from our sliming criminality.

We could never lack tenacity to the dreamy exploits of freedom's soar, for how where deeply engaged in the tender performances of love's recital, we play in our heart's coaxing vision, which shows the romance of our most gentle aspect that is a smidgen of virtue amongst our chaotic dominance our masculinity's worst destructively behold. In these moments the toughness of our coarse nature is held by a weeping womb that causes goodness to come alive in its ecstatic erection, reaching out for heavenly pardons we seek in our angelic aspirations, through, positive, thought.

Could it be that we are fooled by the custom of this capture, we allow to ease us deeply into its supposed comfort, for how we are thought-out without any emotion to react to this disaffected calm, which now seems to inflict us at the deepest levels of our misconceptions that we can not give action to; in this reluctant acceptance to this world's thievery, which truly snatched our fully muted souls.

The complacent disaster of our adjustment bring some boys to the easiest settlement to these chairs and floors, a willing camp out that seems delightedly engage without thought to the overbearing system that will impinge every root of our goodness into sorrow. These eyes and actions I read, are so elusive, in their expression, as to what meaning they want me to define in my search to comprehend their ever switching ideas, where sightly instances of doom seems to cloud the judgment of these thinkers that become consumed with the sorted visions that play the correctional expedition they'll tread with suffering. In this bleak-in reason filled with horror, we're more shrewed then the conundrum of Sherlock Holmes's mystery, already creating the ill trilogy of our chilling circumstance that will claim us into death forever. The morbidity of my neurosis intellect is found battered without my proper bodily portions scattered in a deepness of rouge that shows the color of my leaving spirit, authored by a makeshift knife, which passionately stabs me into eternal rest. The way too small prison cell that births my most intense claustrophobia is heinous in its deprivation to my spacial need; all too mind blowing are these egregious reflections that dominate us with perplexing fear!?

My bitter development steeped in the rudest complaint, is an intricately exasperating stream of fuming bondage, tightly held by the hate of this sulking science, which are my pouting emotions I construct while in my deeply introverted participation to every wretched thinking that ideas me into a gaining nuttiness, worst then a malcontent scrooge that could hate with the most cantankerous disorder.

The teething griminess of my impolite enragement, chews over, more thoroughly then a Rott-weiler that defile its possession into animalistic shreds. The belligerent easiness of this

casually perturb sense, seems significantly stink with rude displacement to all the good that attempts to take root in me, for which I intentionally wish for hate to completely bother me into a raging deteriorate. Surprisingly, even in the self-slaughter of this insulting behavior that can stop the benign essence of my heart's Ssaintliness, I'm given vex thoughts thoroughly filled with irate ideas that are actually immersed in the deepest sense of aggression's calling which shows a knowledge about anger and grief I never knew before. The gentle sensory of the ever domineering perception of good's steadiness, has another half that seems sadistically enlighten, that shows me at this baleful instance the meaning of the inscrutable ambivalence of the madden weirdness which possess my existence into a bitter lost and found, as I come up with smart theories about this brazen, razor-tip, form of emotional and social negativity.

I could never embrace positivity's peace, un-match against this fearless obstacle that is crippling in every protection of its self-possessive understanding that dumb's me into what I'm foolishly am in this suffering neglect, which claims the deepest actions of my Ssainthood's effort to live merrily. I'm unable to claim the funky complexity of this cruelty's, ill-affected demeanor, which fuels the stupid clueless-ness of my bonkers enchantment. I'm thoroughly spell into an ever thinking disorder, for which no idea can make sound the derangement that sickens me with this debility.

The force that ruminates my dumbing ego, guilty this madden Nicky into solitary confinement to thoroughly spread its agonizing favor, all over the soaked dis-satisfaction of my mentally worn out isolation. No astronomical riches could never make better the psychic injury I'm rebuff by, cursed beyond reason it seems, only my unseen Christ would know.

How could it be I'm doom by the limitlessness of this thoroughgoing failure, closely filled into every fecal entirety of this dejection I'm grossly stain into alone. It's not enough for me to cry off this heinous punishment into a cool calm. My wimpy insight is intentionally prohibited by the bitterness of this vague bully that shelters its horror thickly, with its scurrilous projection I'm kept from understanding.

The lowest nuance of my longing sadness, seems pampered by a faithful lover whom holds the dearest moments of my readying departure with savoring lateness, the wisdom of life giving no cause to this silenced development that separates love one's in this grounding finale. The black and white photograph of my olden classics, proves that I'm mature and sorry in my un-enthused attraction to the stupidity of my wrecking youth.

Its as if, I'm held to the slow motion misery of a terminal death, in this, all too slow disability, that is far from spiritually athletic in its sluggish rise. In our languishing, my dieing society sees the other side of this celestial journey, that this un-earthly perfection, shows, which a world learns humans to believe will be better without eternal stop. One should depressingly film the buddying worship the yearning eye's of compassion gives to the hurt comrade, caught deeply into the enormity of this catastrophe, materialism could never come close to pacify, except the un-bought esteem of the magnificent soul. My greatest fortune is in the caressing instances of this submission that keeps me tightly held to the dainty bust of this humanity, whom I come to realize is the allegory of Allah's emotional intentions, from the glimmering mount where the

mysticism of this thumping heart gets its echo; I hear in this lamenting friend before me, that are my correctional buddies, who, through themselves are teaching lessons of some divine.

The all too smooth grievance of this imperceptible disgrace makes me indolent without a morsel of genius to thoroughly decipher the meaning of this suffering that has fallen on my best wits and jolly expressions. When the exuberant life giving sun of my auric performance rises with un-penetrable robust, nothing can claim me into the worst case of dismay, when confronted by life's gloomy pitfalls.

I'm kept in this ever slaughtering development by my lonely, unwilling to die to this heady battle on my knees, where in my fullest wake I allow the occult exclusion of this grim-reaping force to eliminate me into this higher valley, while on my, sinking-psychotic-stance. The fluttering fabric that drapes my casket's cover, which clothes my ghostly elevation in the funeral parlor of my muted observation, in these dark hours, is way too well in its preparatory subtraction. In the fogginess of my historical perception, I see whirling swings audibly dress by laughter that shows the rosy youth of delicate genius. The pleasantness of twisting streets that fail into haunting horizons shows a, all will be well, mystery I wish to only explore in this resplendent linger, an aloneness in this earliest sun-soaked dawn, I would selfishly relish by myself, if I became alive again with freedom.

My studied introspection causes the chemistry of hunger to instigate the biology that juices the glands of my mouth with greed, which is food that needs to fill my empty stomach with nourishment. I'm thinned by this socially pressing exercise, that not only strips away my emotional fortitude from my self-esteem, but also the very void cavity of my caved belly that seems it will swallow itself for a meal. It seems my greedy brain that eats every making of this world's science is what causes my appetite for soul-food. The neurons and cells that flow in my temple makes for the thoughty exercise that shapes my skinny intellect. I'm lost in my hungered study for food, an actuality that I have gripped in my thirsty hands, where somehow at this anorexic moment I cannot bring myself to eat nothing, during this cautiously obscure time. The juices that flow in my excited belly is teased by my schizoid study that are the deep glares I give to the possible energy that can renew my beaten forces into brilliance. My kooky derangement is expressed in the majority around me, whom lost to the socially strident cause that dominates them into a state that is this hunger-less drive which is unable to digest nothing. The bliss that gives their ignorance in these happier characters, gouge the chocolate chips off the cookie with detailed preciseness in this, way too delicate, favor, they show for every morsel of the snack they devour with savoring patients, and at the same time, a cookie-monster manner.

My far-fetch reasoning for a fairy tale escape is un-practical in its hope about some romantic rescue that stupidly believe that a forgiving Queen would capture me back into the freedom of her coddling breast, given me the seated goodness of my throne's freedom else where besides this deepen burial in this suppressive hole. My goofy misunderstanding begins to understand the misfortune I'm being held to, that is without remorse in any way, except through the berserk dialect of my shaky dialog about the consternation of this criminalization I'm cuff to. All in the dizziness of my treacherous sleep, I'm meditative in every crackpot picture that viciously blooms the laws of this destination, and all else that will be a prelude to my brute future in this dunce anguish which toughens my ponder with fear. I am played by the unforgiving reality that shakes

every complacency out my normalized sense, which demands that I remain awake to be exposed to the oddball scheme of this world's ever twisting paradigm.

 The panoramic scope of my shaded insight into the conversations of talkative peers, whom loudly reveal every aspect of their case, is jaw droppingly intriguing in its cinematic occurrences. Everyone is innocent it seems, for how, none, will take responsibility for their actions. The misanthropic mind of my cynical refute should be shamed in my inability to see good in these derelicts. The chaos that looms around these cursed souls, evokes this demonic hatred, that wants to continue to kick these bums while in their ever losing position. What is the sinister abusiveness that compels one to attack someone while already degraded into gruesome lost, a pitiless exploit of this particular, urban-spawn-humanity, that cannot defend itself, which inspires the terror in one's heart to hate, what is already doom. In my angelic repose to find good in me, I'm overcoming this judgmental savagery, that slowly begins to see some innocence in the foul mouth story tellers whom may be earnest in their criminal-less claims.

 The radical perception that refuses to leave me, while in my unreasonable reflection, seems to hold to the very core of my hateful stupidity which only see's all that is wrong with every dirt bomb sucker in this apprehensive detention. Dirty tongues are white with foaming fear, that re-account the moments that a crime was committed. Its amazing how a severe danger in one form, is the same in its hygienic monstrosity, where foul on top of foul persist in its stinkiness this punishing realm scents and breezes terribly.

 Faces have many expressions, but hands become story telling victor's in their airy display, that is compelling in their puppet language which imaginatively point to the other robber who got away, whom was viciously motivated by the greed that derives from the root of a money hungry evil. If only the world could see the story telling hoax of killers who weren't shrewd enough to master, anger's wickedness that boiled them into the insanity which consumes life without an iota of qualm, I, seeing the ferocious residue of their sinister calling that obliterated someone's life, for which has cosmically attach to their dark halo's forever.

 The coarse manner in which some person's are imbued with, that is the averse form of the world's vanity, which presses them, not with the dainty inspiration that we call handsome, but the crude decorations that instigates fear in the innate dimensions of one's heart to stay away. It seems this Yahweh is perfect in its unsuspecting accordance that is the protection they'll need by their repulsive looks, enough to make afraid any nemesis that would confront them to a fisting challenge. Some wonder why they were made tall, for how, it seems their free and civilized reality doesn't need the construction that makes them more erect then wiggling giraffes, where it seems true in my anthropological study that goes deeply into this spirited making that equips a soul with its interior and exterior means, which are the physical complements that are suited for its, survival, when in its, worldly progression. At this barrier base time, gross and ugly, attributes are fit for this dimension that lacks any form of beauty. A beauty may exist, but one in which no eyes can perceive, especially in the form of the lyrical sadness I melodically expose in the story of my personal affliction, I recite to myself as a sad and pleasing song, I can't help, but to play, over and over.

If it were that these inhabitants to this lowest realm, coarse with demonic challenges, were on a higher scale of this mystic progress we would observe that the dazzling bloom of a rose's beauty would be reflected in the beautified existence of their, more, finer and freer calling, while also polite with a positive presentation. More higher though is the best of all these lower children, are the Philosopher-Kings whom rich with the championship of reason's liberal that is free from the world's sightly stupidity, where these intellectually adept leaders, often anonymous, that teach the essential meanings of the world's spiritual calling, is a true beauty that shows itself in their superior ideas whom are close to the inspiration of Krishna's, unseen, sacred, wonder.

The defensive mechanism that underlies the intelligent genome for social survival instigates a person's reclusiveness into desperate action, to attach itself to someone as a form of social protection, to make it in this challenge. So covert are their obvious intentions to be completed by someone else, they want to, go through this suffering by their side, in this awful desperation to belong through this cuffing safety. The tough ones whom protected by thinking that consumes themselves into a silenced safety, lay in their defiance against the girly actions that consumes this feminize environment with vagina behavior. One can be insulted by the false foray they claim as conversation, which is sissy in their pansy intentions that wants to be preserved by unity.

Their exclusive interaction seems to offend me into a bitter disapproval because of my unwelcome invitation to their group's mingle. Fear, more then my shy nature keeps me away in the introverted seclusion of my existence's, self-attachment, that needs only itself to preserve in this observational retreat. In individualism's silenced inspiration that glees the notions of this higher source's thinking into my paranoid heart, I arrive at some fishy understanding about the people I perpetually decode with friendless contempt. I have trouble with courage to muster a pardon into the university of their social thinking. I'm untold to the befriending truth of this dwelling I could only perceive through the subtle invasion of my inquiring mind that fathoms their notions into the story I tell myself in this screwy, lonesome, head. As professor in my study I would come close to these juvenile's feelings, for which assumptions can never better in its dishonesty, I need to be for real, by the introduction of my discoursed inclusion that see's very near, these eyes, that are the gates to their thorny wonder which is atmosphericly textured with a prickling deficit, even in their phony cool-aid smiles. It seems I'm like by me only, without the phoniness of elation's passing, an expiring affection that truly doesn't have no grin to spear, except, through this unfortunate frown.

I hate the family oriented bliss that fills the room, they all, too well worn by the gay infestation that gives a jolly embrace to every word that emanate from their delighted core. This family hood forces loneliness onto my life, which makes inadequate the worldly accomplishments I was told, would make me better with happiness. My unsatisfied essence haven't claim contentment through the world's materialism for which only love can really gratify. This cheery affair amongst themselves, awkwardly leaves no trace of my shadow which could show the evidence of my presence. In this persuasive betterment through my inferior thinking at this lowly time, I tell myself, that, it is, only through individualism a spiritual aspirant could be accepted in the singular space of this starry pinnacle. The deep reason of my ailing heart is confused by the selfish gestures of love, for which I haven't received, that giggling buddies have found, me, incomplete even in the mightiness of my narrative status, whom at the peak of this

stellar mount that feeds me every lore of this correctional tale which deeply pains my subtracted heart with a descriptive malcontent.

The complexity of my fussy conservative personality makes for the socially inept animal I am, all to my protective self, afraid of rejection's abandonment. How could I ever come close to nurture my excellence into something sound, while the beastly courage of this wimpy grief besieges me with subtle cruel. My sensitivity is susceptible to every aspect of decline, that's this world's harsh reality which makes for the coarse welcome I'm afraid to be rejected by. This self-inflicted silence is torment on the liberal openness of my soul's gregarious intentions; how could I be so profound with such introverted conceit. The solitary confinement of my thoughts loneliness is something where certain brilliance is born, in such silenced womb as this, which nurtures every atom of my thoughts tinker into my answering and all knowing supremacy, that makes me a God without a world to watch over and praise me back. I truly seem glorious as this omniscient mention, for a intensely solid tongue of my narrative stamina is praise worthy in its street smart.

As quick as they were in entering their gathered socialization that momentarily quelled the desolation of this world's molestation, they again re-introduce themselves in the punishing tenure of this elapsing part in this correctional development. It seems they were no hugs and kisses that went around amongst this pillow biting audience, for how the ferocious normalcy I've claimed through out this time in the tablet of my heart's woeful study, is one they must endure by themselves in this deplorable re-entry.

My fate in this instance seems to be more outrageously wrong then any place I could imagine. Any other place would make this crucial hole seem better, a condition so wicked in its deepest hassle, which leaves my mind high-strung on the correctional mystery I want to be disclose without this thickly veiled enigma. Television could offer no escape from this locked up brutality, its programed perforces having no calamity that is stark enough to keep my focused attention to its Oscar and real life show. The young soldier in the jungles of congo, seems more well off then we are, where disaster and war is the life they consume with a calm heroism; we briefly escape this correctional torment through the many nations the BBC report on. It seems the far-away status of this foreign elsewhere betters the soul with anywhere but here comfort.

Our shackling reality begins its risky adventure onto our bodies, we all feeling, the tightly slithering entrapments that, cuffs us, from head, to unrelenting toe. From short to tall we quietly ball into precise possession to honor the perfection of this apprehended adjustment in this shackled stance. The harmful illumination of these unforgiving appendages seem to be in a thirst, for our wrists and ankles to be sandwiched in cold steel. Their is no likely escape even in our most heroin dreams to break the slave insanity of this limb harbor. Our self-defense is overly crowded by the bulging anklets and charms that snugly costumes us as violent criminals, who need this particular dress to confine us into our jailed design.

Our ears are stricken with the all too real revelation banging chains loudly announce to our shook souls, that seem, will bound us for good. The elongated mightiness of these coiling links, scale like the creepiest crawler, who's hiss, is the, way too sharp, steely penetration that we hear at every movement our distraught hearts and bodies are terribly emotion by.

The dramatic, entertainment, parental-advisory, value, of this walking affliction, spills into the bothered, and yet fascinated vision of this nosy inner public, that must observe every performing detail of this military line we dazzle this court-house public with. Although frowned upon with no remorse, my heart seeks in my childish pardon, my mind is brainy enough for the inquisitive exposure my eyes reveal, about the inner environment of this judiciary background. In this brief transportation many worlds come alive, in seconds, that are over blown hours my imagination fulfills in its deciphering duty, which uncover the secretive architect, that are hidden, back-doors, and escape sliding barriers, for a judge's escape.

For eons we've been internally kept in the cleat bosom of this correctional shelter, where, at this slightly freed condemnation, we reach the extroverted, boundless halls of society's liberal world. The teasing departure of this, finally found freedom, seem to come alive in this distress awakening that particularly plays the wings of song which keep birds in blithe leisure, that this, Park, is crisp by.

The larger life of my widest intellect is freed by the greater exposure in this honest reality, fulfilled by the airy streams my heart and lungs are gently plump with.

Engulf in the prior ideas of my captivity's observance that drew the exclusive mentalism of my inward imagination, was laden by a false reality that seemed so on-key in my solitary placement, forced alone with all the sadly nasty visions I've believe to be true: my visionary loneliness was unrealistically bullied by the unworthy orchestrations of my basket-case ideas, for which the, not too, past occurrences that took place in this disgrace diary about my life, didn't express itself as exactly the way this whole enchained act was performed. I twistingly accepting the latter part of my, misleading, melodramatic expressions that dominated my phony gaze, which are the psychotic performances, over blown in my self taught fairytale that is more close to truth and far-away from false.

The world's reality is better then the thinking-self, in its extroverted freedom, the close minded trouble of personal thoughts theatrically exclaims. it seems the function of ideas, especially when worried, is a strange mechanism that prepares the self for the danger to come by over-blowing it in the pessimistic temple; the weird but true intelligence shows, greater, even though, external-life, other then individualism will serve a lesser cause: what the mind's eye sees in the worst to come, reality serves as the opposite in showing a more beneficial expression of all will be well.

When I draw the darling beginnings of my past, I could have never imagine the adult dysfunction, grown-up thinking causes to the individual. Its, as if, the more wise the soul the more heavy the entrance of the mental anguish a universe sees fit for the elder mind to un-puzzle. I seem precociouss in my current adult-hood to fathom and cure the many psychological ill's, a soul that have endured several decades of existential study. I feel like an old man with an inside that has depths of dreaming, which the space of an old-soul has brilliant capacity for.

Withdrawn from my hectic past for this momentary freedom, the outer dimension of this earth's omnipotence, fuels me into a trouble-less withdrawal, from what I thought makes me what I'm deficiently am, I assume a, never forgiving, society must hate.

The galactic abundance of this outside exposure consumes my thinking harm into the peace I've magically discovered in the haunting pleasantness of this enchanting, out-door, spell. My previous punishment rested in the mis-inspiration of my failed imbalance I un-normally existed by, me, complacent in my deranged, nutty professor, paradigm, who's odd-ball insanity was norm and suffer I lived to thinkingly appease. It seems I was judgmentally mislead by the physical hoax of prison's dominance, where it seems, its misfortune is intelligibly done by the shaded ideas, my mental illness is truly barred into.

My thinking intimacy excluded all else that was beyond the inner contemplation of this social study, I was by force, held to, in my jail bound saturation. I was unable to include the external exposure of this well thought abundance, that is this, extroverted redemption, made of grass and leisure, infinitely space by earth's ever flowing ubiquity. I was envisionly oppress by every shackled expression of lock-up's explanation, about its woe, and emotional torment it particularly constructs in the imaginative suffering of my soul's profound. And so, my pacing intellect hatefully strolled upon the death-penalty path that harden me into this grim attitude.

In this instance bask in the thrilling coddle of this majestic discharge, the victory I've come to know, becomes better at every second immerse in the rejuvenation this loving capture gently snatches me in; clinch into the smoothen breast of this virginal question that happily eludes me gratified in this enthralling climax, which gives me no answer about my cell-block tirade, except this bittersweet reprieve. The cut and wash garden of my soul seems cultivated by a higher glory that is capable of tending to my soul's inner demons, only for the saving hands that this resplendent quality reveals in my pure intentions. The mechanical intrusiveness of echoing cars, zoom bye without stopping to say hello, to show pity to my teary eyed infliction, I, needing to be babied, from this freer civilization. A romantic savior of this boundless sort, pleases my captured ears with encouragement, at every honking horn and chaotic language I desperately hear from city's laughter. I could hear friendship's gathering that holds society with warm-hearted fellowship, at every whispered conversation, to the lingering behavior of shoes, that stomp smooth pavement floors with the purpose to reach a exempted destination. We silently inhale every accessible aspect of this doting carelessness that a free-speech earth is known for, which inspire the innate language of our contemplative openness we so desire. We imaginatively strive for the tolerant embrace that yearns to enter this border-less reception our thieving chains is oppose to. The gentle lingering I'm kept from, that is this, outside--life, mock the moments of my slight, illusion based, free-will.I know I will eventually lose the bemused euphoria that my enraptured erection is firmly glued to, which is the giddy host of this new-born strain, that I've attempted to stretch with every, mincing, musical note I could announce while in the frolicking radiance that steeps me in its bold jubilee. The compelling heaviness from this highest dawn, emotions me to adore the mightiest arousal I could luckily grasp, that still haven't reach the righteous substance, in this, zenith's immaculate conception. The outer-body-pause, for which I could never possessively establish, must go absent in its departure, due to the, ever developing correctional retrieval that will steal this earthy brightness into the blasphemy of my darkest torture.

Untitled moments like this, riskily looms in a questioning behavior that has no remedying answer at all, which is intertwine with the head-dazing shame and lost, that dooms the entirety of this muscle-less flex I'm unable to compose against this evasive head-game I can't thoroughly follow, while trying to hold onto the interpreting force of my elevated emotions and lower skills I'm physically locked to; which is accompanied by a forceful intrusion that pushes me into the airy dunce of this bizarre pleasantness, I love to cryptically know in my decoding zen.

A roaring mystery hauntingly lingers on the diligent whim of this never leaving coziness, I'm romantically suppress to, me, pleased while in the moaning favor of my keen solace, that is delicately smothered by the rhapsodize pillow-talk Mother Nature reveals in this fearless respire. The gold crusted charm of this extremely raised misconception, I think I know, attempts to show the visionary fantasy that displays within the brainy power where my ideas are glowingly conquered.

I once was taught the brilliant aspect of this ambiguous eloquence, in the previous embodiment of my past-life's unknown that was spellbound by this found lost, I, entering the blear mystique of this deepest, but, light, contrast my still developing story is faintly textured into. I'm cosmically composed through this starry interlude at this richly paused moment, authored by a thick mystifying perfume that raises my soft, but penetrating wonder, sharpened by the gentle casualty of this monk stillness. The airy ornament of this grace's complexity is so blushingly affectionate in its aromatize compassion for my excluded loneliness, rekindling, the stay alive desires my liveliness lost to the possibility of my grieving suicide. The caressing fanciness from this dear bravery, fuels the clever notions that lamp my spirit's halo, which isn't enough in its saintly strength to postpone the disoriented psychosis of my bipolar insanity, that takes me, in and out, the tender moments my life is sporadically sprinkled by, where at this dysfunctional point, hate, must learn me into a combative totality.

I could never be un-guardedly done by the skirted exposure to the dainty sight of this girly twinkle, where I can't allow myself to abandon the masculine quality of my rough nature that will keep my fighting warrior in its ready to battle stance. The treacherous caution prohibited by my ever warning agenda, is skillfully secured by the fully alert awareness I save my life with. My dark visions is heavily vested by the thick protection I build with the solid material that my sense's are strongly barred into, that is this assuring safety in the thoughts of my most strictest stare.

While coming back to the turbulent continual of this miserable, lethal-injection, that is yet to stop my heart with descriptive worry, which I'll confront with my thoroughly bolted tongue in my latter chapters, it seems, at this misery's theme, every breathe I gasp heavily, is wickedly thick by the ideas of this unknown capture. I'm bothered by a stealth serial killer, that is unmask to a saving public that would grant my redemptive safety out this, sternly, flagrant, iniquity. In this fading placement, my death, will be the birth place into the higher savior of my escaping eden.

The belligerent security of my, in your face, notions diabolically nurtures the defended comfort that supplies the strength of my, pit-bull, bark, that makes me cool. Nothing can

penetrate the strong instances my thoughts are heavily gated by. No intruder can invade the bitter peace of this disastrous calm I plan in my thinking resilience against the possible actions that will emanate from this, disorderly world, and its, topsy-turvy, inhabitants.

At this meaningful point, the only challenge I must make myself come to know, is to, preserve my current embodiment for my, free future, that will hopefully abandon these physical, and physiological cuffs I'm terribly held to. Compel by the bullet-proof armor of this warrior grace, I'm furiously teased by this smoldering clarity I perform in my combative thoughts, I'll inflict, on any, trying victim in my knuckle punch reality. It seems I'm purposely bogged down by the hazardous knowledge that must guide me, for the sake of my protection.

The thinking moments in my contemplative past, is now, entering the reality of my deepest lock-down that will start on this waiting bus, which sickens me through the polluted fumes that fuels my emotional riot.

The cheesy bus exterior, children are well known for, in their brightly yellow occupation, is unable to hold us in its innocuous throttle, for which a dirty version for our dark calling, matches the entire broke down presence this vehicle unfortunately displays. Our four wheeled transportation is as equal to the ugliness of our criminal dishonor that is obvious on our ankles and sleeves. Its windows are as filthy as our awful stupidity we once spue with lawless laughter; vision-less windows, that hide every face of this excluded society, from a more, morally, clean kind, through these dark tints.

Every material aspect that is the ridiculously torn and worn features, these seats are thoroughly used by, contain us with a dingy disrespect that hold the stink of our criminality's worst, which is yet to be thoroughly washed by the soap-opera of this correction's unseen goodness, a disciplinary purge that will make us better in our return into the large-hearted arms of civilization's welcome.

In this defenseless silence, this oppression is without any form of rebellion, we doing all, that's told to us, to do. Just as the valiant grace that charges a soul with champion power, this opposite is as strong with helpless courage that demoralizes these hearts into a state of sorrow, which cuts the air open; this pain is unintelligible at this time; their seems to be no interpretation for such strife we're beholding to painstakingly. The bus goes and our souls go along with it, we, occupying this revolting vehicle that is fulfilling the misery of this unrelenting correctional horror. We are lost boys that once were neglected sons, now found, going into the father of this system's acrimonious embrace.

Chapter Two

Deeply Swallowed

The ballooning occurrence of this wheeling transport takes up every breathe of my shock silence. The castigated pedal, that is this, blooming bus into my chasten future I cannot thoroughly suspect, places me in the lost encounter of this penalized forfeiture. Prior to this submissive insult in my boldest yore, I seemed tough with a bravery that would challenge anything in my fighting path, me, succumbing to the strong reprimand of this winning rival, which beats me into the rebel-less combat of this trampled reflection in my flat thoughts about this entire day, and these accelerating moments in this busing hooligan.

 I'm singularly excluded into the dull behavior of my voiceless dejection that is greater then the crying loudness of a baby's wince in their needy midnight. The internally drowning deepness of such throttling restraint keeps me submerge in the flooding halls of my teary eyed troubles, a runny explanation within the pity of my telling self that feels so sorry about my dispirited condition in this losing daze, which sprinkle me with the glimpses of death's withdrawal into the finale of its mysterious exclusion.

 It seems in order to reach my best potential through this cantankerous development that blows the whistles and pounding drums in the heady drama of my battered spiritual, I must feel every harm, immerse in the abundant violence of this affliction's will. As backward, as it is, in accepting this merry-less agony, I wish to claim even more of every brutality that holds me frozen with stiffen fear, so I could teach my lessons in my wise, fathering, future. Although unequal in my stance against the assassination of this stealing vile, I hatefully accept the pouncing knuckles of this attacking peril that courages me with victimized strength.

 The misfortunes I'm being played by, claim two responses, that begin in the innate injury of my unannounced twinkle that seems void of the gleaming evidence of my spirit's luminance, and another in the outer trauma of this orphic reality in its secretive spin, into no where it seems. It feels, as if, from both inward and outward punishments that commences in the inner departure of my canceled contention, I'm removingly frame by a body without a soul, but too, with equal intensity, the missing future of this baffling stop, that punishes me with ditching upset. Oblivious to the healthy exponents of this world's social exterior, I cannot find a drop of wellness in the correctional well, of this, thoroughly hollow agenda, remove by a subtractive laughter that has no bad joke to spear.

 Emotionally rash by the crappy conduct of these death-penalty instances, I'm adversely tracking the former path of an ex-con's cagey hindrance, inwardly frame by the cement abundance of my jealousy's envy to the external pleasance of mainstream's openness. The

intimidating shame of this difficult disturbance, fiercely neglects my pesky despair into the wretched fate of this inducting carnage.

The authoritative fascism of this fuming slaying, oppressively, enforces the savage murder I'm shut into, engross in the gravest slaughter of this boxed in detriment. The snuffed brutality of such flaming idiocy isn't claim for any condemned personality, where the vicious specialty of my luck's beaten, seem purposely lost by the stolen urgency from my life's calling, intently drawn by the Highest intelligent's that inspire this bludgeon battle.

In the opposing barbarism of this blood soak brawl, I must be given a resting pardon in my ascending paradise, which will show, my many enemies that stomp me into the flowery vigil, my love one's will crushingly mourn. If only the Hooty-Tooty belligerence of those smirking officials that stoned me into this buried agony, could see the dolorous details of my honorary departure, through my decease memorial. How could it be the poisonous failure I've succumb to, be the thumping source of this violent irony, that are, malicious, hearts, without a drop of affection for my expired name.

My thorough fatality is stricken by every blow of this piercing insanity, me, claim by the roasting ammunition of this bulletin' riddle that reside on the wise-less ideas of this suffering menace, exposing the ghostly phantom of my brightest sacredness, expressed through the stain rouge of this slain cause. If nothing is by menacing chance, then once in a starry past, in a previous day in my killing embodiment, I too brutalize the innocence of my humanity with homicide, for which, I'm taunted with full reciprocation, through the execution of this day, that is without qualm to the pleas of my dieing gestures, at this, dis-membered time.

If those whom use to the peaceful affairs of their civilly loose environment, without cage and razors, wish to remain outside this bulldog security, they must claim the solitary courage of their individualism to escape the difficulty I'm in; through the temperate supremacy of their reasoning patience that will preserve their prison-less freedom.

In my meanest aggravation I've tolerated the mental anguish of this eradication, through the revelation of my quiet study, me, teaching myself this chaining nature, in the subtle tablet of my bogus mellow. It seems my most clever reality, rest in the inner language of my foul controversy, a ill normalcy I express with apparent ease in my screwy scrutiny. The stormy rage of my inner narration is completed by the bereft madness of this social-less cause, which leaves me unannounced to society's acceptance. A backward receptiveness lay in the weird liking of my reflective and actual troubles that really yearns for, an outer public, whom chain-less with freedom, to pardon my shackled misery with forgiving exemption.

The exiled existence of my juvenile nationality seems maimed by the replete imposition of this hateful injustice, an endless attack to spoil once free and smiley faces into rotten sorrow, through this ditching crusade. While silently disable by the tricky shadow of my arrest-less intelligence, drunk by thinking fear, I'm collared, in, by the missing, but fully present masters that urged the many challenges I'm currently bothered by. Although apparent are these phony correctional figures, the true Authorities that destine this disagreement are happy in their lesson

teaching enlightenment, every child on this motorcoach is experiencing for the wiseness of their sinless senior.

It seems in some jovial past of my care-less ignorance, these ill moments were taught to my inner psychic I never discovered in my childish stupidity that had no understanding of harm's worst. The previous goodness that I've freeingly known compels every moment of this dour half that hated the good of my virginal part, it could not really claim, while held to the mirthful dominance of my facial gestures that showed the purity of my positive youth.

I'm welcome through the subtle insult of this grim engagement, force to learn about the love that backwardly coddles me in the harming shelter of its battering cruel. Foolishly open to this knowing thieve, I innocently accept the stolen reality of this charming illusion that doesn't seem so, at all, in this revealing instance I've become critically wise to. Still thoroughly befuddle by every ruin of this imperceptible invasion that annoyingly sticks to the tiniest inspiration of positivity's lifter, in the emotional arms of my carry-less vision, I boldly dream in this beastly instance the thinking cure of a, self-empowerment, that pulls upon the balance roots of my less confuse past, in my mentally wearisome efforts.

The shaded vision of my kidding laughter was held beneath the blithe naiveness of my rosy puppy-love that showed no likelihood of such criminalization. In this reflective doom, in the thinking answers of my haphazard replies, I'm lost in innumerable ideas about the cause of this reality's purpose I try to expose. The twin laws I must be held to, both good and bad, was cosmically drawn upon the sun-soak start of my brightest life, that frosted me with the gleaming serenity of my smiley mornings, into this miserable punishment in this darken latter, which negatively tighten's me into lifeless thought.

The deeply concerned normalcy of my firmly pause expression, is shown placidly hidden on the immovable form of my stable print, a calm front seen on the facial hoax of my fooling behavior, for which the perturb commotion of my inward dismay is lost in a thick malaise that frustrates every morseling' breath I unfortunately inspire.

The concentrated activity of my anatomy's cells that are hidden lower then the readable breast of my sorry and irate moans, microscopically feels every viciousness from this ardent disease that sickens me with a viral infection during this belly aching chronology. How is it that I feel every gluing' turmoil that coats me into every deepen harm of this toxic defamation, I'm psychologically sick by in my lying cool that shows me deceptively healthy. In the still evolving masculinity of my male nature, my strength gathers muster at every, stay strong, intensity that consoles my tears to stay hidden in the introverted grief of my welling essence, for which I thoroughly feel in the soak instances of my eying spill in the unseen part of my eye balls; I haven't cried yet fully, in the showy sense of my wiping gestures, where my internal heart, although severely dismayed, try's to resolve with a subtle tissue made of reason. I'm not tormented as this singular sufferer that I thought I am, me, joined by the collective participation of many, and practically all, whom in this cruising neglect that is un-just with frustration, anchored by the deepen vision of this heady custody. The indigent cohorts to this bastard tale, that are my fellow passengers, kept in the smallness of their voiceless elementary, are too dumb

in this sorry lost to intelligibly reveal in their juvenile journal's the rioting intrusion of this blink-less surprise.

In my gritty howl, I'm bright with open inspection to recite the feminize part of my open chattiness, I ramble to this speak-less, ever moving domain that listens to every texting speech of my stark mentioning, I pronounce better then sorry-songs that's yummy to the sad part of emotional hunger, when sadness feels the soul empty. I can't, in my personal documentation, master the darkness of this wise-less meaning, that I couldn't just with the deepest comprehension of my philosophical ideas; a thoughtful prince is without the kinging' crown of this bright civil that would give my brainstorm the complacent enlightenment in my answered repose.

My failed quiet has entered the deepen essence of oblivion's nature, in this separated calling that mutely emulates the hush mystery of death's departure. I'm lazed by the dwarf muffle of this neglected deletion that stills me into the dark reflection of this casketing manner. In the shut enigma of my sleepless burial, I see the shackling roots of this chain-gang imprison, I'm newly un-accustomed to reveal in this learning tongue that has no language to describe my awaited destination. I seem to see everything in its purest nature, but cannot fathom the dreamy reality of my personal form. I cannot find every detail of my inflicted meaning, but could interpret every gathered disaster collecting in the filthy aura of this moving expulsion.

Murdered into this lost humbleness, by the darkness of this propelling condemnation, we're severely entrenched by the reaping sickle of this mobile's torment. We're bounded by the courageous flames of this serial anguish, that many times, through many forms, of its bold execution, annihilated us into helpless retreat, where, by the instance of this current slaying, through this unrelenting mystery, we've terribly falling in the black hole of this mazed abyss, gaspingly restrain by this haunting movement. The rolling feud I speak of, is one of the many facets of this correctional world's ill-ism, I never thought would cause agony to my blighted suffer, transportation, exhuming to the offensive front of this prisonlike apprehension.

We're kept by the freakish might of this spooky cartwheel, rusty spokes for which stabs every insulted soul with defenseless worry, virgin, youths untaught to the battle of this defense, we don't know how to challenge. It's through its untold behavior of its spinning menace that makes disastrous my useless argument, ignoring my sorry pleas for clemency, in this raging delivery to dispose our souls into the neglected isolation, in the land fill of condemned criminals, instigated by these tumbling tires.

The dark dominance of these demonically nightmare eyes, are outrageously scary at each tinted glance, unable to trace its shadows that violently penetrates the world's it pushes through. Even while slaughtered by the blurry condition of this sinister shade, I hope to use the blessed recall of my memory's capture, to relive this journey, on my abandonment, from an awaiting correctional facility that seem, it will keep me forever; the brain wave's of our shaken study is unable to trace the wobbly patterns of these tricky wheels, if we wish to go backward in our escape.

We seem held by the turbulent velocity of Niagara's chaos in every direction of this moving infinity. Kept by this toxic river's forceful thrust, the beastly push of its compressed throttle, is unending in its stopping rejection. On and on it goes, uprooting us deeply into the ever-ness of its custody.

The correctional punishment I've already started in, gave no preparation to its challenge, who's eyeless window's, wickedly tint's me into my blind lost, a vision less subtraction that adds sensitive ears to my audible study, which loudly hears every carting substance of this charter buses rumble into our awaited domicile. These spinning wheels, gradually into its hateful motility, plays songs of automotive hell in my crying ears. This too, an unseen orchestrator of my wickedest sentence, becomes an enemy of mine. Freakishly hurtful in these deliriously damage instances, it seems, these rubber tires are too glad to see, and willing to convey our bodies into this unknown barb-wire realm that promises to capture us into its confinement forever. In its whirling refuse my ears catches the surprising cohort, in this, never thought of, cooperation, unbelievably blatant in its conspiring enthusiasm to banish us, into our, four by twelve--hole, some where in this state.

The mazed infliction of its twirling advancement through highways and streets, and question mark circles in unknown neighborhoods, elude the observation of my surveillance, while seriously stuck to the homework I try in vain to complete, for the teacher of my inner thoughts for tomorrow's escape. Lost by the piles and stacks of these many locations, that are, up and down pave sources of these void blocks, entering alleys and countless crosswalks this bus steals me through, without thorough understanding. The manner of its childish movement is intelligibly sloppy in its difficult to learn zig-zags, that is its, trackless confusion, which is knowingly impose on us during this criss-crossing journey the deleterious blight to come in our awaiting penitentiary.

The sailing intrusion of this pirated departure from our prior existence, zooms deeply into tar-roads that are places I've never travel before. All sadly now to me, the avenues and blocks I attempt to remember, are too weak in its permanent absorption in my spongy brain, because of the grieving reality that boldly dominate the heavily occupied sense of my vision's escape from Alcatraz. My search is tired, weaken eyes without attempt to fuel the remembrance of my looking survival to re-enter the safety of my home, I once passionately planned to do. My balling sockets has lost the lubrication it needs, my vision irritated by every strain in this darkness, both physically and emotionally blinkered.

In the fighting faith of my planned resurrection, I schemed myself into the mental action of my soaking observance, to look and not, forgetting to see, every moment of this motorcoach's wheeling performance it travels through, to abandon the correctional home, New York State, Justice, wants Nicky Dorsey to reside in. If I choose even in my unlearned ignorance about how to get back home, my absolute will is to walk every: avenue, street-block, highway, state or borough, to make my freedom unfastened again. In the truthful hypocrisy of my lying objection to this captured jeopardy, during my previous allegations in my planned abandonment, has entered the opposing surrender of my accepting calm. Little by little I'm reduce into the inferior status of this bout-less resignation from the departing work of my intellect's sketch about the names of streets. I'm defeated by the heavily felt armor of these wrapping shackles around my

wrist and ankles. My thoughts are held high in the stink of this bus's atmospheric imagination, while my head is tilted backward in its dismay, about the world I'm truly in, without dreaming question.

This hope I speak of is quited by the feuding beast I'm thoroughly trounce by in its raping pressure, which steals every love for my, stay alive, confidence that diminishes at every awkward offense of this butchering eternity. The open accounts I've realistically known in the abundant expanse of world's, broad-bounty, seems drastically minimized into the jail cell I'm narrowly captured in. Without liberty's releasing choice, the oppressor of my seized calling, forces me to wave the ivory flag of my victor-less fall, me, embracing my enemy's rules; and its, this compliance that gives sound to every emotion that animates a spirit's tears into the bull-horn of this weeping voice, along with the fixtures that prop itself with loud clatter.

Many forms of this criminalization creeps into the senses of our feeling acknowledgment, which are shackles and chains, that's, evoke by the noise of deep pot-holes and broken pavement, which add to our audible woe. These tires are thoroughly intentional in their driven actions, to roll upon holes and curbs to make us sick with annoying fear, at every shaken surprise. Our ears are sporadically reminded of this vexing matrimony, hatefully embracing our limbs. These closely clipped objects are lifelessly shimmering even in this tormenting darkness, bizarrely pristine in their locking gleam that blissfully holds the delicacy of our wrist and ankles, twinkled and harmed.

None else except worry and fuss has dawn on me, during this entire discomfort that consumes every idea of me into thinking anxiety. The catastrophe of this bold question mark, I'm heavy by, fails me into the mystical agony of this dark genius that teases me with close frustration about the why of this calamitous cause; can I cleverly aspire to the mountainous drift of this stream's morose meaning, without the potent completion of my intellect's, sharp tinker, beaten, without thorough brainpower that haphazardly spills a confuse definition about this institution's collar. At this brain-dead slowness, I'm still twitching with interpretation, I confusingly feel in the sensitivity of my essence's observance.

It seems the fibrous plexus of the thickly spun layers about the harassment of my psychotic vain, will need more then a watch-maker's tricky construction to chronologically untangle the tightness of this organization's knotty perplexity. The bristly torture I'm made into by every second of this rational-less approach from this corrective law, to the just of my reason's vengeance in my retaliatory past, penetrates the safest resource of my angelic security into mangled puzzle.

The grasping ego that resides on the thinness of this prickly adventure is as twisty as death's obscure coddle, that is its, capture-less apprehension of a soul that leaves a body for a coffin, me, un-compelled to every correctional good that is an actuality before me, through this, rising, reformation; to not only scold the actions of my past, but also to ascend into the success of a brighter future. Although the unseen meaning about this likely truth over the bad of my behavior, may be a good cause, but I find, that I cannot forgive those tyrants, which I protest without compromise, due to the furtive acquisition of my unworn departure into this jailbird destination;

I'm still scorn by with grudge, because of those courting moments in the first chapter of my life's, judiciary, failure.

I'm emotionally heighten into many degrees of this world's existence, through the burning questions of my imagination's draw about this world's stopping finale? At this, walking on egg-shell's, moment in the inner house of my brokenhearted inspiration, I flux with agonizing haste in every direction as to what could happen to me?

The fizzing chemistry of my over flowing emotions is deliriously robust, a strengthen occurrence that is too much for the flask of my heart to hold, I attempt to figure through the spilling text of my miraculous awakening at this time, where I once was weak with crippling fear. The opposing resurrection to this electric-chair defense seems to be the praying miracle a motherly gesture have done for her departed son. The faint blurriness of this gathering courage, lightly perfumes me into the dreamy physicality of this lightest stance, more towering, then a baby, walking on its learning own.

As the debuting foreigner into the horrid realism I'm getting to know, their's this odd normalcy I'm assembling in my descriptive explanation about the gloomy craft of this environment's heartbroken artistry, I'm skilled by with chain and razor detest. Although once anxiously alive with a talky passion in the head of my melodramatic dialog, I seem to be sane by the actual actions I'm going through, at every revelation of this veil-less progress that steals the tongue of my deepest notes.

I feel annoyingly pampered by the stark truth of the up-front whispers of this stinky grave, while in the learning loneliness of my deciphering judgments that levitates me descriptively insane, on the jailed plank of this capital-punishment. This bitter truth and sweet honesty that perfectly blinds me with an opaque frost, happily conceals my notions with a childish wonder, I'm not, adult enough to intelligibly know, while in this dunce consternation.

My soul is so stirred by the correctional ethers I've arrived at, fascinatingly squeezed at every unclear inhalation: a flirty science immerse in the dirty dreams of criminal's that is deeply ingrain, in the swollen vessels of my depicting lungs, which is the nature of a out-law's creed on breaking societal rules. I'm bright with discomfort, yet satisfied with a vague safety, that is, my reflective silence in this blink-less observation, a wide eye, owl contemplation, lost in searching gaze.

In my arrival to this housing facility, I'm blown into the stuttering disbelief of my stupidest retardation, that brainwashes me into a perplex silliness, due to the incarceration I enter.

A frighten sense of, deja vue, introduces my reality with weird familiarity, through these, new faces, that emerge with a surprise investigation, as to, who we are, at the brink of this correctional shelter. The weaving menace of my idea's developmental ponder, seemed perfectly spun with precise notions about the collective law of this prisoning spider. With the Higher eyes of my meditative monitor, I abundantly imagine, the bulging reality of such criminal teemingness, that is this, crowded place, that spills of youth.

These limited, eye-balls, noses, and mouths that are thoroughly framed by the stolen behavior of this heavily guarded realm, are kept from a public's perspective, that could openingly critique this unknown institution's brutal cure, to our criminal actions. A severely chapped agitation from the lips of their cold stories reveal their pouting tales: I see every stubby bull face thug, cut by the honorary scar of their stab survival; every hairy, strand, that is jaggedly piercing in these eye-brows, illustrate every fiber of their fiery visions that burned a rival alive; in the, oily-eye stairs of these erected visions, I glimpse at the vice of their secret habits, a pubescent boy is prone to in their choking pleasure.

I dislike the gimmicky abundance of this family oriented encounter, unjust in my newly arrived exclusion that can't easily participate with the belong that already resides in the residence I never thought I'll call my home. The challenge that will prove difficult in my unestablished position, is one, where I must be taught the tough ropes, that I'll need to climb to reach the peak of my well welcome comfort. In this start, I'm well declared, not by the known personality of my citizenship to this abode, but, by the awkward statement everyone already here falsely, reads, where my life is criticized with a twisted judgment, which distorts the reality of my true signature.

Although distraught by the separatism of this newly arrived ejection, I'm comforted by the new-jacks I've imaginatively known in the free speech presentations my thoughts studied. The unkindly commencement of this skirmish meeting startlingly terrifies their brink with, all eyes on me, discomfort. The content establishment I so desire, wishes to be place in the future of this destiny I must begin from, point to, tormenting, point. Without the time collapsing magic of my highest sorcery that could genie my life beyond this nervous difficulty, I must comprehend the thorough intensity of this foolishly, virginal, inception.

If I was: already; prior; before; past; history, or, on the other side of this, who are these guys--wide eye investigation, my thoughts too, would be well at ease, where my only challenge would be to ponder the life and times of my newly arrived roommates, which I'm doing to my rivals in the fresh exposure of my observations.

Boxer flossing socialites are fairy well in their amorist embrace. A glee of some, over the top, sort, brightens their auras with excitement I can't understand, a meaningless expression of the worst indirection, that this environment absolutely, forbids, to anything warm-hearted while in this cell-block cruelty. Their worst then glad women enthralled by this intense social possession, that fulfill their breasted hearts with the, brightness that friendship, glowingly satisfy. They seem deeply caffeine with the skippy fashion that a bistro's gossipy gathering talkatively holds. My strongest masculinity at this man-up protest is shamed into discomfort by the gender switching cause I would hate to enter. These cross-dressing turds, possibly, are innately smeared by the bloodiest tampons that shows the burgundy, soak, soap-opera of this romantic reason, amongst these du-rag wearing thugs.

The false repellent of my criticism is truly based in the need to belong to this juvenile sodality. The fraternal gestures of this coddling worship between these comrades causes an untouched envy in my emotionally, un-consoled, deprivation. The uncompleted behavior of my excluded animosity is defiantly furious against the insulting fellowship I'm not hearted into. The

finally found warmth in this desperate capture, makes up for the cold past of their deleted starvation that is now, completed by feverish hugs in this gregarious unity.

Their greedy communion is ungratefully disrespectful to the separated distance of my present departure. The longing silliness of their attachment is bound by the bold fortune of friendship's gathering I'm not apart of. I'm witness to another kind of affection that isn't the pressing form of lips lover's are kissy-sissy by. This elated commotion I'm thought by in my reflection is a brotherly cackle, that leaves me with no voice that would allow me to scream amongst this brotherly choir.

The broken inequality of my wimpy esteem, loosely hinges on the excluded suicide, that would help me evade the cause of this wretched loneliness. My individualism means a hazard in thirst of some safe company I could un-guardedly know without fear of the common behavior new inmates are cautious by, in their way too protective response that stiffens them into a scared silence.

They seem socially bless for how their easily mingled in their effortless collection amongst themselves. My trouble is this suppressive idiocy my awkward attempts to be known, is so dumb with, where every chance of my thinking to enter such society is hard for me to do.

I'm easily spook even by the ideas to stand shoulder to shoulder with my own people, where my thoughts tell me I'm not welcome, even by the ostracized culture of my juvenile peers, who's separate calling is also great in its un-wanted isolation, from an outer public. My childish stairs to seek refuge in this sheltering friendship is wickedly repugnant to the innocence of my distorted focus due to the glee and commotion I'm not crowded into. In my pupil laden anguish, drench with tears and misunderstandings, its like every one else is invited to the birthday party of this social bonding I haven't found, not even by the slightest gesture, from someone that would ask me what's my name in this world's conviviality.

How could my worst worries be fractured by the wicked love of this heaviest disaster which makes my inferiority tall with the most intense mis-esteem I've unfortunately known thus far in my terribly wronged life. If only I could jump into the superiority of this fortunate enchantment, the heart-less darkness of my separatism desperately needs to know.

The talkative subtraction of my social ineptitude is this forgotten disability I'm immovable by, with held into the selfish commotion of my needy quarrels that shows my madness and grieving sorrow's obsessive laments, in my tear stain notes. I know I seem pathetic in my social desperation, but since the birth of my excluded calling, I've been known to stand alone in my defensive survival, without, even a buddy by my singular side, where their was nobody to share, and tell my ideas to, accept the self of my conceited personality already knows.

The self-love nature of my un-adored focus has a fuzzy attention that isn't envision, at all, during this parade, placing me in this conspicuous absence. It seems I'm un-believed by the myth of my long gone mystery, a teenage public untaught to Nicky's deepest midnight, in my muted separation.

I'm a failed nation destitute in its solitary confinement that suffers without the philanthropy of this super-power's emotional rescue. I'm worst then a neglected baby un-adopted by the pacification my missing parents could dotingly achieve, feeding my greatest personality the quintessential substance that would aid my soul's distorted civility into a sterling correction.

My deepest subtraction is stun by how they believe in each other, at every joyous instance they blissfully gather themselves, exclusively, into, they all unaware of the unfairness I'm cheated by, which is the purity of the missing smile I haven't receive, which would tame my outsider troubles. In my emotionally worthless life, thus far, I haven't been brave by the brotherly knowledge that pardons worry into a state of sibling confidence. What feeds my heart-less enmity is the studied cause of this aggravating root that spreads the inferior seeds, planted in the un-consciousness of my selfish vision which doesn't want to die alone. Due to the mastery of my destined isolation my twinkle-less spirit will be unannounced to the stellar rise, a starry kingdom, won't even embrace.

Every morning that I've un-affectionately woken into is noticeably void of the divine encounters friendship shares. In my lacking jealousy I've silently witness the quiet felicity that resides in both buddies whom un-telling about the intense care for each other they subconsciously express. The offed voice of this tossed-out grievance that shows me less than the individualism of my highest man, is this desperate boy in his play-less worst, without a associate that could help my cop and robber make-believe.

If only I could be joined by the flock of this brotherhood that make twins inseparable. The lonesome calling of my solitary individuality, seeks the laughing participation from this lowest kind, I'm superior to, in the tall sense of the wisdom I carry in my unfulfilled, worldly thinking. In contrast to the emptiness of my mislead wins, their positively radiant halos are bright by the companionship that attains the spellbound miracle angels work with.

I never felt the thorough dichotomy of this bittersweet nature, its totality in both these forms, in white and black, shows the vivid, layers specifically in this sugar laced company. Those whom believe to be mirthfully married, are wrong, for which the true attachment I perceive with my ailing heart, the truly divine illustrations many couples in this gathering are frat by.

Stop-less in my emotionally disaffected envy, I'm evoke by the heavy pressure of the light desires this virgo value try's to influence me with, for the exchange of the inner fears that emanate from my introverted calling which tells everybody to stay away. Due to my un-adorable individualism, which is fear that cannot be love, is gross in its suspicious detachment, where, true love cannot be feared, which I need to become within the foul emotions of my deepest cynic.

Their are many tones from this world I have to express in the personal melody of my brokenhearted song, for which the accounts of a buddy-less sort was given. Although not full in its brief emotional description, I know, I'll give more feely thought to my partner-less future again, but at this time, another gross mentioning that suffers me, brand-new, is as awkwardly bright as my loneliness, which is the trenching nuance of start's severe initiation, that seems thoroughly intertwine with a abstract definition of sadness and freedom.

My virginal perception is nervously narrowed by this uneasy newness that gives me my bashful stupidity. I'm dress by the fresh emotions in which the, single-digit, age, during my childish days of my more pure youth, were schooled with books and pencils: it seems I'm newly dunce by the learning institution that brightens a mind with education. I'm again immerse in the uncomfortable position of my first day at school, my parents being these criminal peers that awkwardly watch my every move.

The delicacy of Autumn's windy whispers was the airy thought that held me in its wonder during the social peril of my clumsy registration. Still then, during the threshold of my elementary, my ego's esteem was too sensitive in its desire to know what my class is saying about me.

Some chaotic abstraction of a elevated mix, I would call, pleasant, yet heavily, mysterious, was this forceful gentleness my lost spirit was moved by, which push me to discover the world I must become familiar with in my nerdy caution. My rabbit hole personality is more hiding then a turtle's head that peaks out the safety of its shell, stayingly complained by the jittery cause its nature is compel to express, in its, odd-ball disposition to play it coy.

Even more backwardly soul-stirring is the who-genie classic I'm subconsciously reminded of in this surreal meditation that nostalgically scents the mind-less abnormality of this, sweet deja vue, I cannot thoroughly define; although my infantile perception is reunited with the future of this current daze, I'm still obscured by the vague confusion my toddler moments were dunce by, in my introductory kindergarten, which I equally feel in this current entrance that is un-similar in its full grown dis-ease that is bad enough for my grown-up mentality to tolerate.

Although confronted by the bitter moments of this world's stark causes, in which the deepest parts of me is sour by, I feel a worthy mystique that mysteriously belittles my harsh adventure. The peaceful virginity of my spirits dialect is a shaded complexion made by caramel tones, moisten by the cool ambers, this, clear, Fall, provides in this moony October midnight. School being the kryptonite to a child's freedom, for which this juvenile correction takes its place, postponing my best season that would enable me to express the highest teachings of this vibrant smoothness that makes Planets and Stars absolutely cool to feel and watch.

In the second stage of my captured life I'm frustrated by the delayed participation to this cloud-less season, me unable to blossom in the comforting chill under the rosy covers of my sleepy silence, for which a bawling gesture of my most depress evil, dementedly conditions me with a sinister sadness that has no form of peace to claim in this thorough detachment; from the love of my own life, and the celestial clarity of this crisp wisdom.

My most muted paranormal becomes intensely humble in its reflective challenges that uplifts every wicked ghost that possess the emotions that internally ruins me. Even in the laughable highs of my self-respect that honors my happiness, I'm still push into the heavy half of this turbulent survival that I have to frequently mourn through, while in my most saddest condition, which are the neon displays that my psychology is sometimes, bright, and, sometimes, dark from, in their, hand and hand, animations from this ethereal head game.

Upon the soaring obesity of this favorite luckiness, elation, seems it wants the lowest degree of this dark disorder to fathom the cause this greatest half sadly teaches: the disarray upon which my failed emotions are inspirationally broken, greets, my awareness with lessons that will make my good last longer for the bright future, which will illuminate the path that my positivity will stroll through, eventually, again. Both the tense and gentle divisions made of this good and bad are completely useless in their stop-less satisfaction, where my heart would be immerse in the law that sweetens peaches and butter-scotch, wishes to be included in the bitter taste sour-apples are neglected for. It seems a never ending need for both positive and negative forces influences my heady psychology with the ever spinning intellect eternity is infinitely continuous with. Their's no end, in the, mental, far-sightedness of both these challenges; even with the favorable nature positivity is smooth with, doesn't like the cry-less condition of its always happy vision, which seems prone to seek the obscene half, bother, bitterly controls.

 No virtue shall remain happily exclusive in its ecstatic erection, for which a hidden company must always destruct its opposite half. Their's no need to believe the victor-less lost shall gain in its doom forever, for it, must be un-complained by the opposing nature of this bright half. These two states is reflected in every living being that exist with perception and ponder.

 The always entering and existing, head-banging--force that plays on the soul is a highly inspired continuum only from the cognitive wizard that derive from an almighty calling that coded even, every breathe I respire with cause, other then to keep my lungs filled with the air of my survival. It's this Yin and Yang that must recite itself in everything I do while in the abnormal flesh of this worldly reality that is all too susceptible to the metaphysical habits engross in the disturbed awareness of my screwed up intellect; that is, particularly, at this time frame in the psychological dome of my mental illness that enable both states of glee and depression to perform on the higher stage of my constantly full temple: where their's good their must be bad, and so on, dummy, and its, during the moments of my current madness I feel the elusive sharpness of this blasphemes need, only my psychosis lord can divinely explain and help lose.

 While In the frail communication of this self analysis about my battered wits, I attempt to peel away the challenging layers, I'm always, and, can't, effortlessly undue, due to the smokey like, mind-stuff--substance, my current physic's cannot grab, and temper into cool. My rescued freedom, is to, lie deep in the cause my preordain ailments eventually teaches, specifically through the psychopathic actions from the subtle assault of life's hard to decode riddles. Even while in both, night and day---studies, their could be no notions at all to find the truth of these elusive twins, no matter how obvious are my terrible tears and the climax of my greatest victory's; their's no cleverness that can dismember the brain-power of this mind binding neurological couple, it seems no human genius can truly learn, in which not even the relax climate in a therapist room could help reveal, the laws of this imperceptible terror.

 While maimed by the ghastly performance of this suppressive silence, shrouded by the rancid either my muted intensity is sad because of, desperately desires to be welcomingly included in the sunny-side amazement mirth is golden with. If only the dubious enlightenment I've achieved could be ubiquitously equaled by my peers who's idiocy doesn't care for the ideas

of my heart felt speculations; the thinking thesis of my neuronal moron, philosophically, explains, which is the ever looping, spiraling, elusiveness of, Depression and Happiness.

 It seems my worries means, more, bright reasons that inspire the ingenuity of my dissecting thoughts, woefully push by this abnormality which causes insight to gain sharpness in its penetrating wonder into the known and unknown challenges that un-settle one's life. I seem correct in the prior ideas about my bitter perspective, where language is unable to un-conceal the reality of the bothersome essence I can't get to, even with the organisms and seeds of my deepest mis-understandings my worldly morality has chastise me with; at profoundly in depth levels, where my, hard-to-see, spirit-stuff exist with supreme knowledge.

 I'm so venus in my un-settling agitation, so well worn by the ticked-off aspect of my bawling depression. If my grieving madness could be claimed, then it would be the glitzy glamor that is terribly phony with disapproval in this bloody-die reality I'm brightly sorrowed to: everything is hopelessly false by the glittering misbehavior of this spectacular infliction.

 I'm unfinished by the hostile murder I'm still shocked by. Fresh and rotten, my icky bruises exudes every blow my meanest punctuation has felt from life; existence itself is deplorable in its hatred to the peace I've formerly known in my stellar paradise, for which fuels the strongest occurrence of this irate, earth-bound, apprehension I'm teared into, while lm here, in this godforsaken flesh, that prevents my spirit to survive upon the perfection a Divinity gloried it to be; without a shred of problem, when I was in my heavenly awakening.

Chapter Three

Holy Spirit

I finally rest without no pardon from this stop-less war that is deeply greedy in its capture to bring us to the bottom depths of this world's incessant hole. I stay cuffed without no mentioning to the people around me, except, in the universe of my mind's ideas, where I escape the brutality of this environment's perpetually cruel enslavement. Married by my criminal peer through cuffs and shackles, we wait in a lavish purgatory that is, Bronx, by the confusion of this entire day which is still yet to bitterly unfold.

 A clever entrance before our most sinister hell is gorgeously braced by french manor doors, where the very knockers that decoratively beautifies the oakley mahogany opening, gleams with a golden sheen better then the biblical fantasy that tells of angelic beings whom soar in heaven's skies. Down here in this humanly obese foyer, pine wooded floors keep our dirty soles erect for, continue, to begin its course, to further the immorality of this blasphemes action. The pretty weirdness of these grounds are finished with a gleaming coat, that pleasantly creeks at each movement of our restless feets. The stairway itself shows emotion in the spiraling flow upwards in its opulent ascension to the higher levels that may show more of its intricate design. This banister's million dollar architectural richness swirls me with notions of richer-then-rich dreams I'm unable to get cozy with in my homebound study, in which only my rock hard personality needs to consume me at this time, in the needed thinking of my conforming hell, at the flaming start of this dimension's, well, adorned inferno.

 The innumerable gathering of these frail souls, made tirelessly dunce by this new world, mutes the larynx in our throats, talk-less, but ever thinking and processing of this living horror, at the introductory brink of these doors.

 As we wait deep within, the bewildered roller-coaster emotions of these new criminals are rendered into a expressionless defeat, made mentally sicken by this home's intense cement-block truth. The observer with this inquisitively cosmic eye, see's the soul's defeated desire that are tears hidden in the sanctum of these bodies, which swell with a terrible revelation. The frown face cohort to this apprehension that I'm held to, is also subject to the inner story I recited during my compelling ordeal, in which I wonder, what he would exclaim with his bleeding pen.

 As far as I could sadly remember while attempting to feel through the very confusing atmosphere that was rooted upside down in its sad disorder, wailing souls unfortunately had to stay up not necessarily by the tragic defense of court and bus, but by the blazing mystery to unfold in its stop-less discontent to show no pardon to these dieing boys. A dark character screamed as loud as he can from his insides which leapt in the subtle class I'm currently studying in the emotional bereavement I intellectually document in my adolescent heart in learning. What

I think I felt was without a doubt felt by the darkest slave to the ill tradition of juvenile horror that is play-less without the free will to do so foolishly as free children.

While, in and out, the learning law of this esoteric flame of thinking knowledge, the little mastery to my mystic calling allowed me to observe the nature of this new student I imaginatively guided with my ideas, me seeing dark skin claimed into some worrying wonder that heinously expressed itself in the felt heaviness of his thinking heart. This telling evidence was all in his behavior next to me, as the whites of his eyes, harmfully flashed from time to time in the shadows of the bus's unexplained luminosity: the luminous frost of ghostly white and golden dust, obtrusively streamed into the bus's pitch black. In this reflecting moment about our ordeal, now vividly revisited, the strobes that zebra our bodies and faces, lifted us momentarily from the condemning darkness, into rainbows of white and gold, that gave revelation into every soul's hurtful remorse, which almost pardoned us from this woe; which were the flashing forms of a ROSICRUCIAN like teaching that entered into the bus's moving absence of light, through the authoring holiness of street lamps....

The thinking tears of black skin and white eyes, were downed by a delicate movement that spilled a boyish innocence from his goony, austere, eyes, he too made weak, defeated by this beast we once were entrapped in. His war torn face were bruised with a worry that was as worrisome as my correctional dreams. His twinkling tears that decorated his brute toughness, demonstrated a will not to be broken by the feminine manner of this skirted gesture. As he remained resolute, the internal truth of his soul's softness, was intertwined with an intense, stern, gorilla demeanor, that was all too calm as he shed the fluid of his distraught emotions. A glimpse into his soul was shown to me that this precocious stranger uncontrollably mourned, I, witnessing his weakest moment from the innermost loving hollow of his sensitive spirit, an emotional weakness that belies the human facade of his obtrusive physique.

My self-possessed silence in thinking thought was penetrated by this force that emanated from him, that was so heavy with pain, I covertly coming close to another person's inner heart's shock. He desperately attempted to hold on to his toughness in a covertly struggling manner that is as secretive as my inner grief I consistently play within the safe world in myself that nobody would know of, in my apparently civilize demeanor. At these out-from-know where instances, a sparkly shaman, magically induce a scintillating sorry to his emotionally powered, Holy-Man, expression, that transformed him into a tearful child from this greatest ghost; that forced him to begin to think of all the wrong he has committed against society through the reciprocation of this correctional justice from the fiery staff of this noble priest.

The good magic from a benevolent witch, plays a role, we are not aware of in our adolescent minds, which saves our lives through this heavily gated dormitory that will help us evolve during this bizarrely, enchanted, preservation.

While left in the opulent entry way of this jail-house, where dark skin finally chills without crooks and question-mark associates to acknowledge, I seem to see a wicked side of him I can't help but to fear in the awareness of my cynical caution about this jail-bird personality.

All that is, for the first time presented must be brought to the unfortunate scale of criticism's dissection, which will definitively narrate the closes truth for the observer to clearly follow. My studied bewilderment of my most hulking, block-head, character, is annoyingly trying in its offensive enigma that uncontrollably bothers me through this strongest mystery. I'm not only nervously grieved by the intense immensity of his gross presence, but also this nebulous environment that shadows me from the light of its laws, hence, the on-edge defense that mentally and physically wrangle my malicious dialog.

The burly abundance of his thorough physique assaults my courage into the meanest caution I could prohibit my safety with. I hate the colossal intensity his form is thoroughly rocked by, so grown and defiantly bugling beyond the seams of his intended nature our emerald mother purposely drawn. The close placement in our risk to risk contact grieves me into the harmful wonder my ideas become warrior to. In the clashing misery of my worst attempt to kill my enemy before, he, does it, to me, survival, I know I must withstand the courage of his feuding brutality I won't easily conquer.

Every analytical criticism that's fuel by my losing fears, nervously compels me to dishonor the bout-less actions his apparently cool manner is dull by. Our thinking likeness may be the same, he too, proficient in the security guard behavior his thoughts are tightly uniform in. The warning prejudice I timidly know, may be possessively afraid in the cautious silence of his unresponsive day-dream he's held to, like I'm anxiously am in my thorny version.

He's thoroughly used by the coarse construction his rock and hammer intensity reflects. Its as if, I'm a living witness to this crude making, this brimstone and fire, hardly welds into this grotesque human quality. The sadist artist that is delegated to achieve such eye soaring work is successful in its denial to anything light and gentle M&M is clearly without. The staring awkwardness of this miserable attraction to the puzzled eye's to mournfully behold, deeply glares at the hideous fury that molds the hard difficulty of this bruise challenge.

The living murder of this cruel assassination, in which the ill vanity of this visual disturbance, rules, without question the law of ugly. The picturesque stiffness a zombie's preservation shows, is apparent in his form, which is the aging damage that is over a thousand years in its wash-less neglect.

I'm confronted by the scruffy sloppiness of his unaffectionate display, which seems fuel by the sullen component the force of his nasty origin has authored. In his dingy face, I eye poppingly see the hustled essence that is the agitated confusion his tough aura stains me with, which mystifies me with a dirty substance of perplex and awe. This ragged chemistry's vision must be as intense as the looking fury his spoiled behavior offends me by. Although the dreary brand of this unsavory hue is chopped and sizzled with pimple face injury, a deeper essence resides that shows a lustrous ego that is flawless in its dainty beauty.

The repulsive intensity of this revolting human stunt is thoroughly bothered by the unkindly makeup of this reflective halloween that causes a quiet withdraw into the failed submission the scabby inferiority of this averse sort can do to someone, when their misshapen visionary presentation is grossly inadequate; Its a rejected reminder of their mirroring moments that shows

them why their wickedly distasteful in their outrageous deformation. My eying illusion is unhappily lost by the judgmental sight of this highest imbecility, where something else is thoroughly gain that goes beyond the shallow awareness I'm not clever enough to behold with my, exterior-based, mis-intelligence.

My eying betise is well worn by the childish sense of my worst, picture-perfect, fairy-tale. It's certainly true the lowest scheme I place on this character is hurtful, in which I could be match into, through my life, and current cause that is harden by the unlucky cruelty of this morose destiny I'm scorn by in many dimensions, but still the physical insult of this blinding worry hasn't age me with the creepy scars of death's deterioration, he's grotesque by. I'm definitely not apart of the beautiful sort a Ssaintly shade of ego is appealingly adorable with, but I'm certainly not lost, too, deeply in the egregious state of this tumultuous texture his savage brand is rotten with.

The bereft madness of his combative physiology can never be simple in its defaced politeness, a rocky imbalance so contuse and intolerable to my calm that's evoke by the harden gesture of this attractive fury. The tough artistry drawn on the full blown hardship of this embattled figure, shows the crooked kernel of his parental disorder, whom were age by life to the awful point of their physical foul that still bloom this crummy seed.

It seems this lowest ingredient immerse in the deepest torment of this scary, bold-face, drama, is the most valuable in my inquisitory study by my fallacious eyes that shows the highest purpose his talented preservation is good for; that doesn't have to glitter to show the bright illumination of its hidden power, which looms above the worldly misunderstanding of my face-value perception, in which the highest sources, who too, are obscure in their unsightly divinity, no human can't see, which he truly reflects.

The lowest voice held to my lesser confidence where my hype notions reside is falsely aggravating in its unknown whispers. My mercy-less intrusion into the blinkered definition of his un-lively demeanor willingly describes the phony shadiness of my worst disdain, because of the corrupt mystery of his soul-less gaze.

The brave introduction I welcomingly seek is disclosed by the cold-shoulder gestures of my still apprehensive caution. The miserable disorder of this mystery itself seem more torrentially penetrating as the imaginative sharpness of the rusty crow-bar I think he'll clobber me with. In my awkward attempts that wishes to give in, through a simple ' what's up ' seems pressingly marred by the deflated courage I try desperately to fulfill in this social disaster, to the person that is closes to me at this sensitive time.

The victor-less acquisition of my struggling attempts to seek his community is wickedly hampered by the unkindly emotions my introvert senses shames me by. The cold tongue of my shy notions is selfishly creepy in its idling bravery that is lost to no contact in my people-less exclusion which has only conquered myself. The power of my solitude is plenty in its studied claim to the magnificence of clever, but I yearn for the escapism that could save me from my self taught environment, which is an exclusive misery in the elevated temple of my life's investigatory thinking that want's to leave itself for the outer furlough of some social contact.

My unforgiving calling is this suffering isolation that seems to be the reclusive curse hiddenly expressed in the offensive character that is similar to me, whom suspiciously provoking, not necessarily through the scorn and murder of my protective distrustfulness, but through a deeper need in me, which wants to be befriended by him. It's here my deeply dark likeness is given a trenching richness in the thickly layered resemblance of my lost twin, whom emotionally found by the wary indictment of my leery prosecution that holds his character in the blaming contempt of my scared ideas. When their were no trust worthy partners in my meanest hell, I've found an even blacker derelict that cannot see its own form I seem to find comfort in. The riddled lost of our vision-less dysfunction held us in the obscure midst of this answer-less abyss that attacks us with the brutally sharp, head-games, our traumatic headaches attempt to dull.

Left alone in the simmering envy of my radical separation that suffocate my communal tongue, in which, lay my gregarious insight into his world that I critically harm with the abusive ideas of my intolerant xenophobia, I embrace at every second in my waiting silence.

All the evasive attempts of my schizophrenic departure from within, to begin outwardly are unable to be employed in this un-abandon pressure that internally rules me. Their's no hoax I could use in the definite capture I'm thoroughly held to, through the strong illusion of my ailing imagination. My greatest happiness seen an escape that is fueled by a bold hope, that is, just as weakening as the frightful agony of this inferior torment that brings the best sucker out of me. The flimsy tremble of my calcium deprived back-bone is this departed courage traded for the puny safety of my vulnerable guard, in which the breast-bone that is the frail structure that holds my ever failing heart, is loosely protected against this opposing rage that would postpone my thump forever.

My sharp apprehension is as penetrating as my escaping elation that is strangled with a not so intelligent buffoonery, where it seems even if my freedom was openly granted I'll be stayed by the incredible brain-wash that would wish my enemy to execute my dear life. It's like the bothersome part of this delicately psychotic trouble, is one, made of a blistering chemistry that is at the most subtle form, heatedly chaotic in its all too terrible disorder my heart is desperately fasten into during these mentally raging seconds. And the other part of this blear existential exterior, although steep in the outer performance of some rescue I could achieve in a simple, hello, is this heavy coldness that balms the chest and courage with a snail pace, do to the shivering circumstance my grief stricken biology is chillingly surprise by; through the ordeal of this realm's suppressive obstruction that prevents my greatest freedom.

The showy aggression of eyes are the usual torment which is the instigator for a louder horror to displace the common senses into fisting lost. So my defensive avoidance is unchain by my eye contact I disrespect this close neighbor with that gives no visual acknowledgment he could be aware of, which he could mistaken as an attacking welcome I sought to occur. The larger force that abounds in the hidden material this dimension is currently fueled by in its abrupt sadness and emotional homicide, is the metaphysical slightness I cannot conceptually capture, so I blame the closes person next to me for all the wrong I've been damned by, so far.

Although my sight is unannounced in our, eye to eye, connection, the hidden gossip beneath the dark sheath of my afraid flesh is cusp with ideas about the fictitious nature of the person next to me, only the fallacy of gossip can wrongfully reveal. As intense as this, false, all in my head, detest, I'm still receptive to the joyful unity a brotherly fellowship is good for in the hand shaking pardon that would excuse the vicious behavior of this battle's misconception. Although my language is advance in its, laughy-giggly, progressiveness, still my critical monstrosity is compelled to mutilate the man amongst me that complain my awareness with the imaginative insult I play out in my rude mind. Everything I dishonestly think of is the identical projection shown on the timid tabloid of my paranoid language, that, he, in his emotional disturbance also assumes, probably.

The cruelty of my judgments are self inspired in the most crooked way, but it seems my properly expressive nature counsels me for the purpose to stay alive through the wicked personality of my, guards-up, preservation. What would I be if I introduce myself by the smiley exposure that would invite attack to my weak openness. I'm unable to receptively show my powerless welcome to the intruder I still don't know in this mistaken identity. I'm well thought by the suspicious half of my searching reason that attempts to know who he is, although steep in the frenzied chaos of this dark curse, which I've perfectly aligned my many descriptions to the freak-fest of this sadistic abnormality. The problems I've known since the inception of my story, isn't nothing compared to the ever dramatic behavior of this unrelenting surprise my caution has personally known due to this mysteriously nebulous man: I'm cuffed to a secretive serial killer that could obliterate my life into the fiery calling burning spirits are eternally fried by, if I was too cool.

The thinking defense of my alarming warnings about the man next to me, is unfortunately fueled by the humanitarian failure of the gravest kind, from the noir that seems to consult the forces of tragedy, the lowest relation of my chocolate-ness is prone to in their well versed wickedness. My awareness can't help but to explain itself into this worrisome retreat to increase my preservation. The more tanned by the graces of this black nature the more the misunderstanding the frustrated subject that brandishes this ebony shade. Even in the highest state of a social civility without suffer and obstacles, still a combative chaos looms over the life of my freer ilk, who's mental strident is as brutal as the harsh physic's my lower class is subject to with cheat and murder. While placed amongst the lowest degree of this criminalize inferiority, hate, is as constant and willed with vim and vigor in its hurtful scheme at any given time from these melanize souls.

The negro mystery of his deeply question mark tone, although perfect without a spec of blemish on the onyx hue of his flawless presentation, still, I've succumb to the wicked possibilities of his attack that may end my young life. I'm to brave to reduce myself to the pure-breed nature of his nerveless lull, which scares me through the combative form and plotting attack of his delicate personality that keeps to the supposed innocense of itself. It seems a un-pronounce warning was taught to the deepest conscience of my terrified prejudice to fear the profoundly tar beauty he physically beholds, thats at the scorching level an african sun can color.

I've been imperceptibly given an undeniably complex, stereotypical, supplement that have been thoroughly hidden during the baffling genesis of my worldly birth, and throughout the

wise-less life in my past, that tutored me of this racial knowledge I express through the subtle aspects of my slight racist.

I feel self hating and injured by the ideas of my questioning safety, that is fueled by the deep immersion in the social misunderstanding a mainstream clientele is always subject to, in their backward conclusions. The self-deprecating ideas about my ilk would be unquestionably recited to the most open and tolerable nationalist that unconditionally adores their brand, but, while in this safety-less dis-ease that raises the self-protective admonishment that would execute its similarity, must be claimed to insure the survival of its ego, so it can live to speak and happily breathe; although my, jet-darkness, is true, his ebony disorder is as dangerously trying, as the horrific pollution that fumbles my goodness into something worried and cruel, due to the intensely, stinky, shock that has gone quietly beyond my colorful concern and vivid vex. If their was hope in such saving extreme, then I would wish upon this undimmed twinkle to come along and coddle me into its shimmering illusion that would collect my savagely mutilated body and emotional portions into a, less, hurtful fairytale, which would be appropriate for a virgin child to hear and see.

I've been passively told to run in the other direction when in the violent presence of my fiery shade, and this radical danger is all too loose in the close company of this nail biting behavior I'm unexpectedly blacked into. My shook sense is beyond the serene awareness of my safest observation from a heavily secured tower my thinking happiness can freely laugh within. It's true my suffering is untouched, still a wicked intensity punctuates every inner fiber of my oozing emotions that spills the innate soul-stuff that is unfortunately expressed through a crying person's tears.

The infuriated exclamation of my truest horror is blatantly recited by the raw cruelty of this, jet-toned shade. The surviving caution of my saving exclusion plays to, itself, since the perception of my likely death by the similarity of my murderous kind, I frightfully became wise to. Although my loneliness is wickedly profound, but the greatest finale my existence could be stolen into is drastically shorten for the livable long-term of my worldly eternity. My current life seems more honest then the supposed form of this spirituality, where spirits get their wings.

My eternal best maybe properly fortunate in its divine state, still I like the likely idea of waking in the world I knew since I was a child, although fraught with depression and challenge, which quickly aged me to this stern moment I exhibit my cold sensibility. Their are those neglected instances I've felt a grave force of separation that told me to take my life, but lessons I've silently observe from my, long-gone-peers, proves my self-reservation is a good preservative for my wisest limit in my elderly demise, where I've lived a full life that witness the birth of my grandchildren.

Defunct by every manner of my executing pessimism directed in any direction I could evilly expose, has consume itself through the brimming fire of my own assault that steals my teaching thoughts into silence. I've fatigued the inspiration of my effete mastermind, I think I possess, into the renewing pause, my blazing study is frustrated out of, in this reconstructive leave, where my brain patterns will be able to consult its mental details into the intricate design of this elaborate journal.

While in the still learning evasion of my less thinking surprise, a lesson comes to me In the vacationing vision of my moral temple, where nothing seems nurturing and honest, as the ethical reality of my perfect suffering that seem to shape my life for the honor of altruism's embrace. What if my joyous days were continuously full of ecstasy that would prevent the lessoned entrance of challenge to sculpt my wisdom into something charmingly meaning. What if, then I remained un-disputed in the victory of my flawless existence, that kept to its championed self, without a another victor to share the feelings of my win: a shared laughter is better then the tragedy of my separate smile that has no giggly companion to sweetfully validate my jest. The hardest obstacles I must disapprove in my conquering attempts is a necessary evil for the mighty tears and troubles that some how makes me better then my beastly youth.

I've been blissfully grasp by the belly of an excited virginity, me standing as tall as the angelic desires that make these fairy butterfly's stupid, which evoked my most intensest lust for failure, that then, held me to a driven discovery to reveal my best. What if the prescribing hierarchy's whom drew the world, fulfilled my worldly mural to be beautiful without the educational scars of ugly's humble. If my spirited resurrection stood only in the heavenly form of its misery-less, flair, forever, then my supposedly great enclave would breed my lesson-less heart with abject stupidity. My profound encounters although harmful in its tragic embrace to my emotional psychology, seem to be a magnificent torment that shows the significant sensibility I behold in my injured interpretations, I scroll onto the noteworthy portions that is the entirety of this adolescent verse, so far, I wholeheartedly recite with lyrical acclaim.

Finally the locked barbarism stuck to my risk and ankles are becoming as loose as the evolving ideas I play in my intellectually blooming head, where a freer theme is beginning to grasp my exiting life into my newest dimension I'm fresh to; that's without the heaviness of steal appendages caught on the delicate form of my formerly hampered anatomy. The philosophical victory I've mentioned, becomes the light hearted satisfaction collectively shared by the peers of my busing misery I've spoken for in my ailing ordeal, who too reaches the finale of cuffs and shackles, we all now vividly perceive. It seems a thinking knowledge is first in its departure into the withdrawn peace I've believed, in the dreams of my unrestrained successes, which then is exclaimed in the lower force of this physicality where the fleshy aspect of my uninhibited life truly dominates in its dream-less reality, that feels my escape not by thought, but, by a realism I feel in, action.

I've become awfully adopted to the un-lock serenity of this momentary freedom I relish more deeper then the dingy notes of my already expressed troubles. The broken heaviness of my puzzling expressions in the retarded pace of my jagged reflections, I've made descriptively flawed, should be transformed into this quick moment that is intense in this opposing victory of escape.

As I advance into a higher calling up these jail-house stairs that may harbor the needed treatment I so deserve, due to the regularity of the unrelenting terror that began with a judge and counsel that thoroughly soak me with the boldest doom I'm still damp with in this severe cold. The walking progression into my greatest elation hopes to reach the freed medium, a roaming public values in their exquisite saunter. I hope to flaunt my cool in this un-conservative society

that tells me to loosen the tyrannical mistreatment this cruel gestapo government has wrongfully influence me into.

I once was played by a terrified halloween that was costumed by the horrific cufflink which displays me in a place of a captured savage. I'm now openly spirited by the personable makeup of my freest identity I wear as my flesh.

A very surprising spectacle anticipates this newest arrival into its bizarre threshold during the day of this entire celebratory evil, I'm emotionally halloween by. I'm mindlessly, un-hearted, through the tricky intoxication of this funny force that keeps me as mystically dizzy since my entrance into this world's brink and current continual, I'm deeply folly in with a pained and wondering pleasure. The newest parts of me I mysteriously feel, at each step upward, I increasingly achieve, seems to mystify itself for the prior basis of my true essence, that has, magically, in it, every source of my making that softly cradles the reason for my influential name; which compels my fate's predetermined issues into this earthly motion to guide my life in its exact direction. The gently glimmering brilliance I stupidly muster about my slightly un-veiled experience in a forgotten life, believes me wondrously alive at every instance I gather into the unpredictable edge of this exciting world; it doesn't seem possible, because it all seems un-definitively strange while in a terror that somehow goes hypnotically--soft.

The space-bound delicacy of my, origin's, highest sanctity that held my fresh spirit-stuff in its new-born place, ornate, in the slowest motion the quizzical warmth of its brightly clouded serenity that soothes my stern ego back into the perfection of my dunce child, so a new realm can swallow me whole without protest to the known disability from a harsh penitentiary; where my entering life will aid a completion for my life's story only a sky-bound dictator inspired.

Ah ... this is it, my latest epiphany in its unborn twirl, yet to be un-screwed in its blazing delivery, over the throne of my pleasantly unseated inspiration that wants me to pursue the answering verse my soul needs to play into life's melodies which may reveal the song hidden in my currently clogged instrument. The, wish-like, praise-worthy, notoriety of this merciful manifestation is this gorgeous residue made of this wise-less honor I'm not yet advance enough to champion, which emanates from the starry-stuff where the felicity of soul-power first occurs. It's as if, I see the fragile fumes and tumbling strokes embedded in the sweetly suspicious nature, the majestic surgery of my mending lord, delicately constructs my life with, while in the holy-ghost operation I'm going through in both bodies of below and above. Its a grand order, although, somehow watched, that my worldly existence still can't comprehend, except through the confuse state of this awe-struck separation and baptismal genesis, with one eye of this world shut, and one open in the realm of miracle.

I'm happily abandon by a slippery elegance I properly admire from afar, where if my closeness to this skilled mystery would leave me without the teasing wonderment this ecstatic feeling has done to my intensely mellow esteem, that this, truly full, high, is capable of doing to my ghostly senses.

I seem drunk by the faint cause of this betterment during the point of this worst journey into this jailed criminality. We wait at a desk, topped with documents and a phone. I rest with my

new-jack peers in a destination, that is this, cool darkness where our thoughts can be easily felt by our ever solving intuitions, while in a cushy office that is carpeted at every easy step into many notions we casually breathe.

Usually the isolated blasphemy of my worst separation would disclose the deepest emotions about my absent form, from the affairs I could experience with the human community; and the attach subscription to any world I dreamed to be concern within, is remedied in this grateful entrance: their were days I felt thoroughly withdrawn from the social solution that is the basic requirement to nurture a soul's survival to stay alive; my inner aloneness always quickly became the outer opening I wanted to share into, with any form of public.

The wandering theme of my gypsy stroll into numerous dimensions that swells my observational study, then becomes the mandated, extroverted, realism a participating presence from somebody could satisfy; in which I haven't un-guardedly found, but gained through the correctional cause that embraces me fully in its world. Although traumatize by the emotional conflict I wish to un-include during my stay in this criminal expedition, I'm reflectingly glad to belong to the social harm of this world's personal betterment to the egregious condition of my prior dominion, I knew, hopelessly about; while in the lonesome life that wrongfully dressed me with the heavy force of strong perfume, invisibly layered me with the un-sound quietness of death's sole departure.

The sharp grief bound occurrences of this world's, subtlety, despicable, attacks, is more good to me then the dulled out brutality that kept me away from the collectively flawed criticism's of society's misconceptions. Before my chain-less days, I've been stuck to a buddhist mountain in which my mastery suffer attempted to evade civilization at all cost through the misunderstood, not so, great, selfishness of, alone; the dis-enchanted power of dominion seems dreamless, in which a peopled world can help my person to learn with characterization. It seems their needs to be a delicate balance between separation and belong that must be upheld in the precise exit and entrance I place myself into, to medicate both emotional portions of self and world in order to keep my psychology well in proportion.

A ever sudden hokus-pokus, in its weightless hint is heard within the evasive wonder of my tickled perception, which seems to believe in the passionate character of my current sensitivity, where the sporadic grace I thought, is as, loose, as the spontaneous idle wind gingerly chimes, shows the permanent part of its softly blurry abstraction I constantly behold with the cushy finger's of my un-harden en-ternity I mold into language.

Always haunted by some ambiguous mention from a unclear fantasy the purity of my child was close to, and has mindlessly lived in this realistic world, in which, the somewhat strong sensibility of my, able, young-adult, mentality, I reasonably conceive through standard thinking, restores its senses into what I delicately can in this tipsy mis-intelligence that recites an already experience episode I watched in the sacred epitome where destiny's are shown. As I come to the truest comprehension of my tough reality, I seem utterly doom without a modicum of favor from mercy's rescue, and, it is, here, the emotional scintilla my weak luck serves is through the womb form of this breasted betterment. All else is foolishly lost by the inexperience behavior of my

wise-less youth, which makes me feel unquestionably condemned, but I'm still given the un-abandoned lenience her never failing attachment to what she has drawn, as her, son.

No historically enchanted muse through spoken-word in golden-bound-books that recite the lore of Jehovah could come close to the enrapture such a mother has given me from my unknown birth to the awareness of my appreciative presence, the wisdom of my aching heart honors as sacred; their were days a heavily imagined finale lay me beneath my earthy burial my self-extermination nearly authored, but a face too innocent, unaware of my, sad-to-death, thinking, gently sprung off the ill humor of my pondered extinction, along with the childish memories that coddled my virginity in her soft lap, which kept me at my safest ease as a revered human being she honestly esteemed. Their were times my protective passion saw the true completion through, death, in which this highest, paradise, new-born spirits are prayed into, is one, I thought she should enter to escape the savage part of life's trials; I felt that the virgo that gave me breathing force as this tough boy, needed to take her flower skirt personality into the great atom that will make her heart beat, infinitely, rouge.

I've explained fall as the blessed days I should be respected as magically perfect with gifted insight, as I saw through the wispy cold, a happily wondering, crisp, face, I've come to believe is the reflected divinity I must praise before she's withdrawn from the hurting hole of this earthy environment we're stuck to: we're mortals that must gain, wise and lessons, to develop into the house of this supreme teaching, the soul, brings back knowledge to.

The reflective brightness of my tender complaints about the forceful misery of this love, dumb's me into a bygone affection that is slightly loose, but near, in my relapsing reach into some good genesis that cradles the theme of this femininity's maternal power. My newborn mystery hold something as tall and wide as the heavenly abode that learned me about every action of my life to take place in my worldly journey. And it is, here, such notion I've been majestically told, showed the blissfully-wrong, unity, I'm committing in this instance to the joyous female that help nurture me with peace and pure embrace, I unfortunately was detach from for the purpose of this criminally convicted ordeal.

The still numbness of our eye soaked conversation is completely fragile with move-less sorrow; an imposing will of sadness that seems perfect in its bawling agenda that must bitterly claim its balance, was held down by the euphoric moments we've shared in our past, that's now dramatically insulted by this cruel insurrection.

With the shred mercy of this call, I'm still given no power at all, as we thoroughly exclaim our anguish through disorderly tears that's shed between both these buddies. I attempt to recite the particular characteristics of my current drama as prisoner through the heaving expressions of my continuously welling soul. I seem wickedly postpone by the dour cause of this heavy occurrence that doesn't want me to speak a word at all, but only the language of my weeping strife. All is painfully said and done. My time on the phone is over, and the phone disconnects, " Au Revoir Ma' mere "

With no delicate breathe to behold in my relishing silence, although once corrupt with abject frustration, I've loosely held the nursing bosom that smothered me into my prince-hood which proves I'm still good enough to be deeply venerated.

I wonder how emotionally woven the attachment our vital cord, was, during the nine births of my hidden conception in my feminist's belly that derived from the cosmic yesterday I once was conscious as her doting ruler: I believe I was the father of my mother in a, past-life, in which I saw all of my daughters and sons out the sexual form of my hardest ejection that bore this particular pink themed offspring full of loyalty and glee at the sight of my, now, babied specialty, she's come back to planetary life to love.

While in this insightful perspective I once was manned in a body I'd eventually abandoned after fulfilling the paternal cause that prepared this, current day, which seems all too mystically true in this believable appearance my beloved un-dieingly praise, as I did before, when my, mommy, now, was the daughter I glorified greater then this mighty lord.

If I was once rich with a multitude of family and friends in this, early, massiveness, before, which my meditative introspection see's about this, past-body, then the excluded birth of my current theme in this solitary life was do to the patriarchal status that affectionately presided over my abundant children and comrades; I once knew what belong was, as host and superior as head of a large family and cherished by friends, back-then, which then is served as a lesson in my, today, of what it is to be alone: every waking life out the stellar womb, this starry Empress, re-enters, me into, doesn't become what it was earlier: this soul-stuff becomes the opposite of my past-life that is independently balance, currently, bran-new to learn a valuable lesson that moralizes, a evolve personality with a compassionately, progressive, wise-hearted ideal.

My intentionally departed virgo was said to be this hopeless hero that I must be without, in which, I'll mourn far-off in my meanest separation, while she, always remains in her skirted essence by her holy self, with only the sanctified duty to pray that, all will, be, better, during the harshest cause I'm challenged by. My ideal dreams are uprooted for this deserted troublesome, which leaves me kiss-less without the hugs and asking honor of what I would like to eat and think in the easy mansion I once grew in, with serene and blase comfort.

These forgetful gestures came breasted in their presentations that show themselves as once given me the vitality to live during the fragile stages of my babied growth. Wickedly rude in their abandoned silence, now I've come to fully appreciate the pacified senses she fills an entire galaxy with, which is the cosy, held-tight, love that protected me as a great victor. Although sympathetic to my chaotic nature her maternal kindness once frequently flourished me with, seems to embrace the chilling ferocity her virginity closes me out of, for the sake of lesson's teachings that will better my actions for my civilized tomorrow.

In entering my next torrential status within this entire doom, my thinking sense still can't believe is true, I'm directed to the room I'll worry myself to sleep. A disproportionately large and physically messy staff member presses me with a foul excitement to take a shower, and wear the clothing that is the bridal gown I'll style as a new bride for the hardship I'm marrying as home.

I'm close to learning my lessons through my sorrowed crying, in which my thorough regret hysterically falls upon the living life of my greatest abjection. The tender inequality impress upon the soak cheek of this deplorable recital is the perfect evidence I'm in my deepest mourn. The complaining urgency I cast off, flows beyond the eye drying measure that's unable to soothe the monstrous duty of this sharp purpose which penetrates the howl, I sing outward into disharmony. I'm indicted by a hidden slavery, untold to the larger community I once was freely amongst, that's without the abusive authority which now forces me to cry out the essence which pours from the roaring opening of my leaking eye. My vision is swollen by the ideas and actions of my bad-boy past and unforgiving presence that causes the weeping excellence of my drench remorse.

I'm certainly a criminal by the keen adjustment of this accusatory law, but it seems the weakness of my criminality is washed-out by the bastard wince of my childish frown; its like the toughness that I've horribly known is traded for the good behavior of my bawling disgrace that proves my un-hard innocence during these emotionally violent moments.

I'm placed in my wildest solitude made of filth, unhygienically wrecked by the careless nature of this grotesque boyhood potty. I've entered a silent part of my dirtiest question, garbage by the dingy room of this bathroom that holds my lowest personality in its constant place my watery reply expresses with, thick, puff-chest, sniffles; I cry as profound as the newborn moment I came into life while at the courageous twilight of this washing sin that flows through the runny waterfall of my soak and sullen sight.

As I begin to unveil the deepest negligee of my jail-bar life, a extraordinary, mutely, disturb cornucopia of emotional and worldly issues are quietly composed into me by the shaded fixture that the translucent doom of this lustrous shadow illuminates me with, while in this slammer's room. In the composed mystery of what is next to harm me with raw and abrupt indifference, I seem light and less afraid while in the total disorder this latest nightmare wrongfully soothes me into. I'm controlled by a calming volume that softly depresses me into the mind warping failure that shows my, strange-vacationing, cell-block, scowl. I seem to be this once boyishly great adolescent gladiator now trounce by the winning barbarism of this, conservative, adult, enforcer that ground's me into my baffled and hypnotically confuse reflection without the properly thinking evasion of my un-hampered liberalism, along with the euphoric courage of my free-spirited heart that makes me defiantly brave, while I was in my unblocked stupidity.

The feuding bliss of my brightest light-mare has become the dim attraction this exist sign shows, in its, hope like display. I seem I'm being transported out the enormous crack filled avenue of this current direction for something vaguely new without fully engaging the internship of this system's, bossy, punishment.

In this, door-less, darkened, room, softly dressed by the lamp of light where man once stood, a moon's graces seem to slightly ease its rays into this sleeping area, where, I'm this definite prisoner. My lingering reprieve seems to be this most lonely sorry, where my child like suffering seems to be the parentless cruelty my new-born days unquestionably need.

While watching the silence of my lost character, I'm aware of the creeping quiet that has in it the un-found questions I'm still yet to learn the answer to, in this enigmatic presence. A lost intention is elusively steep in the future of my greatest superiority, where my nobility will be kind with a esoteric knowledge that will reveal, other-worldly-intelligence, that this Cosmo-Conception teaches.

A surprisingly misunderstood awareness lays within the softly abrupt mysticism of this mysteriously thrilled incomprehension. The clear but foggy intuition of this loose spiritual that is hidden amongst the awareness outside of me, from this unspeakable beyond, blindly submerges its tinted ideal in the central form of my weak subconscious I attempt to retrieve in my meditation. This, tough-love, seems to be this dazzling thought or crystal like idea, I'm not ready to behold in my, still, unnatural form, although my serious suffering has come close to the complaint, mourning hearts express about death's terribly riddled submission. My puzzling dialect is bound by the laws of my human meaning, where I have to unquestionably experience the cruel after-math of this still knowledgeable hell, where I'm not saint yet, like this brilliant virginity.

My ego is kept from being in this truly restorative paradise, except, through the fine whisper of this careless magic that is hard to define the ecstatic tease of its barely there existence; it flows within the unseen airiness that fuels my hidden wings to expand into the possibility of this master's forgiveness.

I arrive at the ultimate love that stimulates the broken hearted failure of this current, remain calm, instruction, I've unknowingly achieved. The cascading wonder of this enchanted mercy directly into my, now, royal heart, is replenished by this gleaming novelty that begins me into my, more, advance, fresh-man. This eternal spring produces the spillage once good for eden's environment that emotionally washes me ordained with a cooler mind that will help me prevail in my still evolving narratives.

The unearthly resurrection of this hypnotic redemption, that is this, ever increasing, new life, that is becoming me in this, supernaturally, infuse, room, seems, emotionally maimed by the slow motion goodness the elegant reflections the faint-red, and moonlight illumination could wondrously reveal. In this blended enlightenment, I'm menace by the colored redness the exit-sign aura's my bless notions with, that evoke the charm delirium of my rosiest smile, at the sublime performance this escaping emergency is blood-light by in this glowing metaphor, as a, sacredly veiled king, who's enshrouded in the great solitude of my worst hour, which is characterized in the ghostly costume of this affectionate period. A lord radiant in burgundy dramatizes itself a grand priest through this bloody mars that is intertwined into hues of cranberry streams, which then richly become the scarlet rubies of crimson peace, at this, past-midnight, reprieve. In my lavish observation during this impressive communion, night flashes a scintillating clarity that could only be shown through the flickering silence of this suffering, while at the same time pleasurable in its epiphany, that covers me and this atmosphere with the sparkling luminosity of the, HOLY SPIRIT....

Chapter Four

Reflective Ascension

During my day to day survival in this penitentiary silences me into thinking question as this insightful observer. I've encounter a grisly menace in the introductory abandonment, my condemned patrons, are forever new and old to. Something entirely frequent in its displacement comes and goes again with an intent to cause havoc to the definition of what's familiar. This brick and cell subway station somehow require whirling souls to be turned and spin as often as waking faces that cracks a smile in dawn, and then becoming dark as midnight in mute distress. When an un-shallow investigation of a character starts to reveal its deepest value, it gets stolen into this mysterious midnight, into another criminally convicted flaw, that's chained with a razor tip punishment these roamers must newly enter again. The late night elsewhere into the very back parts of chronologies darkness in no good by leave, is a brutal question-mark crime to the senses that becomes established in this comforted ill, they must, regain, as newcomers into another cell-block institution.

In both mind and heart a traumatic disarray so emotionally and intellectually heavy, is relegated to the internal parts of our degraded feelings, that blight up the steady streams which inwardly flow emotional, and in external form, into this packed facility, ready to replace the present ebb, that must continue a similar departure of export into a final resting place, hopefully. This abuse full of obscurity is hatefully that, in this shackled darkness we constantly must traverse during this ever abandoning midnight. The unavoidable occurrence of change, is damaging to the established soul, where in these moments of leave, tears, are painfully cast, in the moments of this severe detachment.

The business of this revolving immensity, in this, entering and departing, over packed, chaos, is one I wish I was aware of, so I could have already understood with my metaphysical sense the terrible surprise of this agonizing challenge this barb-wire suffer thoroughly places in the ruin hidden-ness where ideas arise. A greatly savage truth happens itself realistically radical to the nth degree, where innumerable burning questions slaves my opinions with the black version this correctional state dominates. My placement in this secretively awe-struck status is gathered in the meanest collection, dominated by amber tones that range from coffee and cream into the deepest raspberry preserve, that's also amongst a very tiny dash of ivory sprinkles. The unreal sorriness of this bizarre tradition grips through chains and steel barriers, the best of my optimism in this abundant cave that doesn't lack darkness.

Grieved by the defunct introduction of this pessimistic realm, the inflamed inner psychology of my most delicate kernel is decomposed by the force that places this blatant inferiority on me, through this maximum subtraction. The grueling blessing of this hacking detention, is of a sort, possibly, life planned for every adolescent to help their proper development, which will aid their

greatest evolution; too stupid these crying interpreters to the obvious good that is before them, that only the deepest thinkers can see, as meaningfully appropriate as the bitterness of lemon's cringe, that is this, sour curse we must consume to make us better.

The innumerable derelicts in this emotionally chaotic debut, are thoroughly layered by the countless details of their ever expressive criminality, through the captured peopled form of this juvenile diversity, that are these, copiously barred youth into this death-row kingdom. These apprehended jail-birds burst beyond the physical boundaries of the vestibule and living room of this bulging facility. It seems we're being prepared to be sold to a greater market that awaits to further the chopping block madness that will guillotine us into finale's withdraw forever, a forgotten separatism that will have no news to tell about the execution of this story, which will split my chopped tongue into permanent mute, where no one from the compassionate world could at least glimpse at what is trying to be disastrously said in our desperate need for forgiveness.

The disguise commodity of our criminal expense makes us the subtle slaves directed by this unlawful jurisdiction that keep us in its endless contempt, not for our criminal ways necessarily, but for the pay-day agenda from a imperceptibly brutal warden, whom inspires this blackened evil. The undercover exposure I'm unable to fully tell is block by the thick nuance, that is too much, to interpret its precise retail, although we are the frustrated inhabitants that actively sustain this prisonly wealth I cannot give value to, while in my infuriated depression.

A agenda both mentally and physically belligerent renders me as combative as the moment I passionately fought for my escape out the condemning will of this entire criminal enforcement, that steals me into these very moments where I personally exclaim my madness to myself. My placement in the questioning midst of my current community hopes me with a societal relevancy that shows to myself I am apart of, although madden and strong in my argumentative secrecy I'd like to reveal in any debate with someone who'll gladly fight me during this brawling welcome. I'm worn and riddled with the questions of how my condition is seen by the juvenile interpreters who's hidden ideas are as present as the heated intelligence I passionately screen in my intense day-dreams.

The drilling nature of the spinning chaos within my absurd, serial-killer, silence, seem quick and constant in its spiraling ability to exist in many extreme forms when lost in the subtle ideas of my calculating wrath. I somehow envision constantly the menacing horror a waring suicide-bomber hatefully implodes in its savage power. I'm evilly sown into a very bad instance that is the ticking bomb stuff that can explode at the tiniest offense, which is this sinister intricacy kept within every volcanic whim of the most minute conception, that gather itself without the conscious okay I think of as intelligibly sickening to acknowledge: its like the unworthy foul that shouldn't be given the emotional and mental complaint of my annoyed irritation, still becomes fully aggravating at the smallest form I could despise; although I try to force any calm of positivity into the stiffen cruelty of my stale attitude, a major force trench in the hardest difficulty that's too heavy for me to, expunge, this grave and contentious possession.

I seem to suffer from something quietly impassioned in its undetected request to play with my normally, good, sanity, that is this ridiculously torrid force that is unimaginable in its obvious

psychological attainment within my possessively disturbed mental temper. I'm insanely perplex as to why it causes me to think an innocent world is the cause of my sinister dilemma, which diabolically enforces a severely inspired reaction within me to hurt an unaware society with the harshest misery I could bitterly inflict. The miserably failed joke that I am is completely hurtful in its non-stop massacre that terrifies my emotions with laughed at cruelty. What can I blame for the consistent abnormality of my hidden strife that bitterly authors every corruption felt in the emotional breast and dome of my worst attention, that this unsympathetic audience believes as this creepy delinquent disgrace. In my obviously weaken innocence I'm talk-less to the outer portion of this community's injurious rumors, that losingly tucks me into my head-down shame.

I wonder when I became conservative in my selfish seclusion, individualistically narrowed within the personal limitations of my sole personality. During this self constructive period of my bitter man, I'm emotionally tasting in my maturing adolescence, seems to be a terrible glimpse into a grumpy future I'll hate to be exclusively in, with this mean ego. This strictly self taught hardship, seems to be the perturb result of suppressing the natural inclusive-ness of the liberal soul.

Like this great infinite universe, I'm sure I must borrow the collective spectacle of the endless gathering reflected in this starry dome; if the greater life of this stellar superiority is unlimited in its evidence I observe in such twinkling university then it is up to me to possessively teach myself the expressions of this social attitude with my current community, I am, apart of, no matter how terrible are my separatist ideas I bitterly believe.

I seem more wicked then the combative senselessness murderers express in their physical destruction they could externally inflict, but the hurtful troubles that resides in the inner decay of my thinking drama is so extremely self deprecating in its brutal intensity upon the sensitive essence where a murderer's actions first derive in harsh thought: although a assassin's emotions are release outwardly in its executing catharsis, no bettering conclusion is yielded in the dramatically stayed wrong of my thoughts rotten suppression, which fills me ill and cantankerously dirty in my dreaming evil I wouldn't know how to destroy if good would fall on my hard head.

The easy part of me all too responsively dangerous and menacingly destructive in its inspired chaos, to every enemy I believe offended me into my disturb perception, is disastrously envisioned through the many diabolical forms of hate's expression that I'll inspire myself to be fueled through, at every vile recite I heinously perform in my broken heart and head. As truly innocent as people really are in the smiley forms that angelically shows them as happy children, the retarded belligerence of my cruel feelings wants to prove myself through the annihilated value of this hacking ruffle, which pushes me at every positively thinking second I attempt in my saving refrain to ruin all that is truly polite in its likable sinlessness.

If their could woefully be an ultimate devastation to my present terror bound with the un-holistic and emotionally fragile awareness of my most heart-stopping sadness then its in the egregiously feeble form the failed manner of my life's story that has so far been deeply ridiculed in this doomed reflection, themed, with an utter lost. its as if, the work I never really expressed, but vividly dream of doing, can't be shown to my un-accomplished pride, which is nothing

worthy that my inner complaints could be quieted by, through some form of success I could present to my inner snob.

 The dementedly failed aspect that harbors itself deep in the livelihood of my heart wrenching challenge forcefully exclaims this loser disturbance I'm silently maimed in, at every less-then brutality, I would think, would, stop my dear heart in its grieving place; but the tight emptiness of this wicked, look-down-on-me, laughter, keeps me drastically going as I live in the hurtful midst of this thoroughly intentional dis-ease that makes me mentally problematic to myself and the world.

 I'm degraded and personally bullied by the inner royalty of my upstanding personality that believes its better then my more savage character that got me into this entire mess. I can't be the crazed stuff talked down to in every meeting I have with a koo-koo professional that thinks themselves much more brilliant in knowing the ideas about my selfish misconceptions that is highly critical of society in a dangerous manner. The crazy guiltiness of my clever retardation I journal through the telling observations in my battered notes consistently speak of sickness through my life's development in this very secure criminality I'm forced in, which seems to make my derangement even more upset.

 I did wake up positive and stable within a weak form of normalcy today but eventually mislead through the unfortunate day dreams that reveals acrimonious conclusions that makes me feel bad about myself in every unforgiving honesty that tells me the sharp truth about my current condition, either past and future, in this terribly hurtful reflective disturbance. If torment is true then its proven during these instances I'm wrongfully alive in, that's the corrupt awareness where my feelings feel unconditionally spoiled. I feel as if the entire world has conspired to hate even the simple, god giving right, I breathe in this hateful abandonment that fully punishes me insanely distraught. Unquestionably before in my most prior distress, I've desperately cried, but the most profound mental dialect of this brutal cause weakens me greater then the smaller form of my previous torment I knew unfortunately well of, in the soak sense of my wash out reflection, that composed the thick blurriness of tears, which abundantly streamed, as if, it was the last hour of my life, into this mysterious eternity.

 How could I ever thought it derangely possible that my meanest meditation is ruled by a foul disorder my shaken mentality bizarrely exclaims. The sadly bothered intellect that shows signs of an abnormal decay is disorganize by the scary witch doctor of some deeply screwy insanity that drastically plans me with the gravest recital thats terribly ruin by the essence of this blasphemes force, I can't believe, I'm holding in the rotten fragility my lowest ego performs as intelligibly afflicted in its functional retard.

 My current achievements all too mixed up in the terrible negativity of this failed state, has only garnered the inappropriate criminality this cuff and shackle reality believes me remarkably berserk, in the crazy temple of my self inspired homicide that could detach me from this vivid restriction, forever, into something possibly much more gentle then this demented jeopardy I hold in my rotten head.

As far gone into my inner sadistic that shows my social-pariah, at its, neglected, all to myself, anti-social, epitome, reveals this, odd-ball, shallow--withdrawal that isn't the conceited sort made of some face-value mis-intelligence, and other aspects of vanity's shallowness, but a deeper sense that is in love with how the mind's metaphysical mechanism operates while good or bad. And in this lunatic instance I'm the brave professor left to myself to thoroughly ponder and heavily feel the grave tradition psycho's go through in their disturbed, head-banging, sociopath condition.

If I was the captured serial killer questioned by detectives, then many of my emotionally distraught responses would revolve around the euphoric purity in which a sensible stability occurs from the great act of this heart-warming romance. Abandoned by its charm and felicitous welcome, my darling void from such smiley face bliss, all too sensitive in its gentle nature, gave life to the consistent opposite I speak of, in and from, this chained mansion, while in the twisted theory's of my prickly conclusions this jail-house perilously allows, which fuels more of my loony troubles.

To claim some sort of sympathy from, badge, wearing, enforcers, I would reveal some family oriented wishes, full of holiday glee and reverence for my acknowledged existence. I would spoil the deep resentment for my loco actions these gun slinging investigators would have for me, into something that expressed a neglected theme since the earliest child I remembered, as not being surrounded by love one's, whom could have restored the angelic behavior within my Mother-Teresa heart that would never inspire a scintilla of wrong; not even toward this world renowned demon that presides over hell in its horn and tailed viciousness.

The many facets of love's recitals seem un-included in its stopping approach in my separatist life, where I've constantly adored the current company I'm amongst in this brutal placement, I seem wished into, by my prior deeply reclusive desires to be apart of some community. Although teenage and some what, grown, way above my elementary past, I still childishly harbor the sensitivity my little brother's ilk emotionally require in their easily crying moments that gets hugged by love's approval which better young hearts bright and good again. It seems my inner physic's lacks the outer extremity of my healthy adolescent form, where my insides as this constantly weeping baby is reflected in this weak child not yet mentally and emotionally grown into the self-esteem that makes adults positively stable and proper in their wise abilities.

Since I've been the emotional bearer of this benevolent complaint, I know those limited faces full of abject distant and harsh isolation that keeps them lonely and restricted in such sadness I have to embrace at this point of my individualism. Here, the loneliness I think I suffer from becomes the void intelligence where I could learn about the inner feelings my sub-conscious holds, where my best potential is mystically hidden; and in this self departure into my deepest meditation, will restore me, back into my successfully emotional achievement, I wish, to now, permanently gain, instead of the genius about myself I have to study, which I'll someday present to the appreciative world when it encounters the abstract parts of my creative sense.

During the severely wreck situation of this horrible experience, I see unrequested comrades that lay in the un-loved defeat of this benign apprehension that has left us for good, it seems, for all, un-desired eternity. My empathetic attempts I try to express during this tight misfortune

made of weak hearts and frail minds, through a simple glance of compassion is unharmoniously blocked by this dramatically lost and sad, vibe, gravely marked by a divine cause that must foster the ailment of this vomiting hurt.

 My conceited conflict is more problem with the, lack-of, portion that's within the constantly functional part of my emotional disturbance that fuels my grieved hysteria, which goes un-cured in my defensive need for the tender nurture that descends from the positivity I wish I could believe in, all the well days of my life, until my merry decease. My self-pitying desires that worships every lost that been stolen from my life, seems to be the domineering challenge that constantly plays out overwrought on the canvas of my always battered emotions. A more subtle form within this ever grieving nuance, is absolutely mighty in its feeling thirst that cannot be easily quench due to the deeply searing experience my emotions encountered. The profound revelation I was wrongfully engross in, was severely beaten into my, still, mourning worship of the, same-blooded-ally, that conjures the feelings of this never ending past, which is shown through the emotional form of my current dislike for my life that lashes out due to the early extermination of my long-gone sibling, whom entered the elevated omniscience of this starry space too early.

 My obligatory reason that got me into this criminal placement shouldn't be judged as insane and wrong, by the fair few whom rational with reason's, just, approach, that would follow the vindictive right I unquestionably tried to express. The fury of my hurt harbored the vengeful monstrosity I promised to inflict toward the culprit that snuffed my little brother's life into the good infinity of this highest gospel, I hope will preserve him forever, until I'm born-again by his stellar side. The vividly irate revenge I sought for my brother's death, had to be heinously honored by my vehement stance to impose the unthinkable ill, imploded on my life and family. Although alive, a deeply slain sense still resides in every awakening through out my conscious days that plays him alive in the dreaming form of my loving thoughts for such virgin spirit. My debilitation is terribly weaken within a heart, that feels every visionary stroke, when my inner ideas draws jeffrey's smile in his pure baby.

 A dear child of eleven I've shortly known, is as much the spry beauty in the un-vain spring that blooms quickly in its fancy, which seems to have died, as fast as its new-born debut, I've seen in the rose of nature's garden, reflected in the rosy form of this long-gone boy. We both were planted in a nurturing belly that bore the feeding root of our mother's placenta, which feed us alive into this world's entrance.

 The day I believe to be merrily true, became this sad, unknown, mistake that waited in the demonic orchestration I never thought would perform in the realism of my most, harsh, thought-of, reality. Until the very finale of his last breathe, through the necessity of his life's fully lived withdrawal, I thought he would reach his long-term demise through a natural, elderly, death, which reached its way too early subtraction that keeps my little brother from being alive, as a wise senior by my side in our shared golden stage.

 Love became the grave issue for this entire assault that mistakenly targeted the victim I'll eulogize while in the page-tearing-chapter of my greatest affliction. The associates I've known, only in, what-up, salutation, were the best-friends I constantly saw together as good buddies,

whom became too close in their limitless camaraderie that led one friend to think it was okay to cheat with the other friends madame. When love caught jealous wind within its enviously perturb sails, a bloody danger would become a awful theme for the target that would be passionately sought. The cosmic fate of this disastrous necessity, was unfortunately shown at this destined time, to only a watchful omniscience that knew of this calamitous fatality. Love indeed is mighty in its goodness, so impeccable in its intense perfection, which is fully adopted in its opposite catastrophe when caught in its boldly expressive tirade. If one is found in the brutally distraught problem of this venomous half, the amorist romantic becomes a passionate murderer, when angered by love's mindless jeopardy.

The virgin-spirit whom only reached eleven years on the planetary grounds of this ever turbulent earth, dwell amongst an unknown danger that was about to be killed by the strong jealousy of this puppy-love romeo. Although I wasn't there, the many ideas of what happened is constantly gazed in the tunnel-vision of my solving distress. In my learning from the remembrance of the people whom were present in their re-tell, I logically construct the situation I've heard and seen countless times in the puzzling infinite of my reproductive mind, as to how, this violent, love-story, gone, bad, lead to my sibling's, died-for-love, expiration.

I was reversed, on how, a target lounged on a corner, all too chill, while in the freedom of its whatever youth, that held a care-free attitude in its un-suspiciously cool feelings, the wonderful atmosphere of this great creation of life can peace, which also claimed the loafing admiration of the smallest member that derive from the same internal space of our father's loins. Two still living souls were socially jointed in the chatting midst of their hanging-out fellowship that became disrupted by shots directed by the flaming source of the heart's great envy, which hatefully bore the uncontrollably derange holocaust punishment that left both dead forever. The intended target was dotted by the piercing hell from the fiery wrath of the love-sick, gun-man, while also obliterating the life of my little boy into muted shreds.

No mercy was ever asked in the sudden deletion jeffrey didn't request in his instantaneous demise that is all too true in its destroying testimonial evidence which riddle the angelic dome of my lowest aged sibling. Gossip told me of a very stealth episode that plays a diabolical terrorist whom furtively crept into the abrupt surprise that gave no warning to the, glock-and-popped, dead. A grape-vine opera portrayed the passionate killer in the most, heinously, secret, attack, in his approach to expel the thief, that took his breasted lover, whom really is the skirted author of this entire tragedy through the pilfering bullets of this very scorched carnage.

How could a ruling zeus be this eminent lord whom casually remain uninterrupted in its almighty okay to my brothers atrocious neglect. If this supposedly supreme benevolence has infinite love for its humanity, then what I've been mislead to religiously adore, has reach the phony revelation that fueled me with ideas of some, saving, grace, that is eternally secure forever in its protection of all that is good. Instead, a deviously un-enlightened disclosure stood so surprisingly un-pacified in its vulgar vacancy, as the riddled, left-for-dead, slaughter, a child's body was shot and holed with, went without even the entrance of some divine that could believe miracles as true.

Due to the godless ambush of this unsanctified disgrace, I now know why atheist abandoned the questionable author of eden's fib, for the truest self that is solely realize as its own, it must preserve as a supremacy itself: the self governing alpha I am, already is and always have been, righteously lone in the powerful individualism I really control, rather then some source that I'm taught is beyond me, I must wait on to deliver my successes and protection. The saving evidence I sought is in myself, as a creative power to implement and deconstruct the paths my life follow.

A tender aid I hope sought my sibling in the comforting coddle a feminist pacifies, went untouched by the breasted cradle a female spirituality didn't show to this aborted baby. If catholicism says women are close to the maker of this universe then it could be abandonly believed, no skirted form through some mary like miracle, showed its rescue for a child, I know, cried for this supposed goddess that would restore the dieing with a emotional beauty even the lowest aged man requires in its care-free child.

It seems the punishing place in the lowest suspension where hell resides, is erected in the actual reality I've lived, in my enormous woe that is expressively intense as the religions that scares the soul with ideas of sin, which will keep me damned in a fiery hole for all time.

In my earnest worship of this promising Jesus, I've glorified the ever lying grace that have chosen not to show itself during the last drama my brother screamed on earth, this un-proved ruler never evaluated.

Although I'm not fully withdrawn personally from the teachings of some savior, my tiniest soul-mate have been purposely omitted it seems by the absent punishment a deity allowed. Sense then my slight awareness of this sinister side became crucially born into the torrid perception that made me let go a majority of my good man, for something terrible in its functional deceit that incorrectly remained disturbingly ardent, and horrifying in its god-forsaken consistency. I still certainly heard the frail whispers of this supreme being, but lost the great fear I once knew in my innocent child that happily believed in a starry majesty through the ever praying ritual to this highest ultimate.

I became deformed in my rejection to the good sense of this bright spirituality for the bad deception of the dark hours I sought in my merciless attempts to viciously eradicate the person whom horribly orchestrated my little brother into his eternal burial. All the times I passionately stood in the wicked part of this lower hazard, I've felt the question, some pure grace, talk to me, as better, then what I tried to heinously become in my evilly sick attempts. Even while in the most gross form of my dreadful disorder, a clear notion sought its way into the flaming breast I held in the cavity of my personable hell, I was, and completely lived in, in my emotionally and mentally ugly damage, which believed in the death penalty principle texan's seek against a severely convicted culprit.

Although feverishly pessimistic, and conservatively hectic in my erratic reactions, still, the liberal sort, attempted to turn my foul behavior into something less rowdy then the damning ways I believed as the best response, as civil, in pay-back murder.

Now, and madly then, I vividly imagine the cool attempts in his, looking-up-to-me, approach, whom sought the validity I could respect him with, through the honorable acceptance I gave him. Its these dreamy reasons that filled me with a severe contempt that fueled my terrible purpose. Although vexingly complaint with the sinister force held in dante's demonize basin, my innocence was all too evident, out loud, to the angelic witnesses that know me of absolute good, whom too, full of pure virtue, affirmed my rivalry as I did, at the moments I change into the complete opposer to the revolting source that unearth my sweet brethren.

In these hauntingly real seconds I became nothing to christ as jeffrey did in his dieing infliction that wasn't made better by a single touch of some spirited intervention. I always learned of this power, which is spread and victoriously omnipresent that would send some winged sort, out of its perfect eternity, to maintain all that is good in this world. And this fairy tale account have fail in its realistic lost that went missing in its unholy lie to prevent the most diabolical injury a evil person can fulfill.

I wonder what my cartoon network brother supposed during the, smaller, then a second moment, he reached this infamous demise, we all must succumb to. Although death is unknowingly radical in its indiscriminate entrance drawn onto our dieing destiny, still a living program is somewhat dictated by humanity in the preparatory prospects of their long-term life. He became excluded from the planning immortality human's grow into, in their, long lived senior. While fully compounded in my reflective affliction, his death seems more heavily buried then the suffocatingly covered kind a grave ditch sadly submerges.

The flesh slain casket he personally costumes in my hurt ideas, seems to go beyond its, own, morbidly muted nature into this highest death sorrow cannot even mourn, where the ruthful wails of this subject's emotional wince isn't enough to exclaim the gloom that fills the heart utterly grieved, and silently sullen, through the mum behavior of my deepest regret. I have no descriptively complaining speech that could recite his short memorial on this foul planet-earth. The basic oppressive truth of my incessantly simmering lamentation is heart brokenly, that, in its very ruin ability, to feel, total hurt. No intelligible answer that could resolve my grief from a responding lord, could never better the inner funeral of my sharp depression that is fully utilized in the weakness of my, crushed, heart.

The silently doleful part I despondently entered, was more muted then the suspended placement deeply unsound in the trench that keeps jeffrey from talking forever. No reason at all from this unimportant world could have removed me from the fraternal topic I personally studied lonely and mad. My senseless individuality became such, so peeved as to why his exemplary form of sinlessness had to die in such a dirty way.

All he did was cartoon himself to sleep, and wake into the bliss his nature expresses in his ever smiley childhood. The all too true narratives to myself that flashes the episodes of his good past, dooms me completely distraught with an unspeakable danger that would even defy the creator of this enigmatic universe, whom is baffling in its suffering need to allow hate to exist in this earthly plain full of contempt and emotional terror, I have unfortunately come to know in the very hard lesson, this is, life.

If the eventual stuff made of hard lessons, are usually fully bloomed in the adult stage a grown man can tolerate, then I'm wisely early in a very harsh way to the purposeful necessity, the seriously adverse teachings that learns me into my ethically better man. If so, in my possessively felt learning, how could death be a just cause to help form me into the valued position wise men are glorified for. Possibly its this hidden reason mystically concern with my spiritual development that has instructed every chaos in my life to balance the karma of my yesteryear, I cruelly imposed in a past-life.

Could it be purposely intended, I'm being learned through a actual good that is being restored through this, integral, to my, destiny, distress. The thoroughly felt function of this theological doom about the revenge a monk law reciprocates, is very slight in its hurtful trickery I'm terribly suppose to, in the heart and mind of my ever suicidal day dreams about this dolorously flawed situation I'm sadly stricken in, without escape from the supremacy of this omnipresent law. I'm hopeless against the almighty repair that wants to wrong me absolutely harmed, and remorseful for the offenses I've committed in my heedlessly tyrannical cosmic past.

The vengeance sought for another, is one I took up, in search of the shooting gunmen, with the most handsome firearm, that was as pistol and grave, as the out-come it unfortunately intends. The wooded piece I held in my waist and hand of my dangerous bosom, was perfect for the retaliation of the baby, I help nurture in its, goo--goo, gah--gah, infancy; his newly conceive flesh was pampered with the freshest baby powder, that made his new-born smell even sweeter then the organic scent is holy virginity applies to a pure baby. The sadistic infliction I held to, was do, to the innocuously soft disposition a baby in kicking wake showed, at the, big-brother, presence, that, gushed, with a smiley face--too, full of bless and purity. I was disastrously fueled by the reflections of my unity with this pamper-wearing class that is close to god, whom feed my intent to commit open murder with my triggering justice in any public way, if I caught him in society. The many nights woken by lips of drooling saliva, from jeffrey's only, gum and tongue, but, no, teeth--mouth, was tamed by my protective cradle in big brother's hugging arms, that quelled his monster seeing ordeal into something that made cool, the virgin-spirit of his dependent life.

While nurtured by the wisdom of his mere presence, the street mentality I knew of, envisioned the, too-wrong-to-talk-about, possibility, he could face in this deeply troubling world. Even amongst the abundance of many protective men, he has in several blood-brothers, I still knew he won't be immune to the mean street rules, that is pistol-whipped in its elated sight of gleaming fire-arms. The gun-slinging author that sent him to his post-mortem state, stretch him into the high pinnacles, where a lord stands in comforting wait. His resurrected solace is in talk, of a better life, in his next incarnation, in a more fortunate womb.

The duty I was concentrated to, was to fully avenge with absolute slaughter, the bastard that obliterated my siblings rise into this unknown realm that is starred and spaced with mystery. My ill was controlled by this reflective selflessness that was lead by a response, from the very young pupil of this brotherly friend, whom impassioned my killing peer-pressure.

From those precious and bloody moments on, I carried the most dangerously loaded artillery, I could get my thirsty palms on, that I got from a Haitian assassin, who escaped the haitian military. The stereo-types full of, black-magic, voo-doo, mystified me into something seriously sick, which zombie me into a forceful daze that couldn't uncover this heavy witch-craft. I've only come to remember the deeply searing tales of the life his prior journeys exposed in the revealing details of his brutality. I remember the fearful day I sat in his kitchen, where the stories of knifes stuffed into bodies were exclaimed as sickening, as the kills he dictated in his military tyranny. I couldn't really sleep, up to this day, from there on, with, one open eye, I leave wide alert, due to the unforgettable accounts that told of descriptions of stained and thickly coated blood, which soak machetes with gruesome annihilations, that I know, keeps many murdered ghost alive in their, un-dieing, creole, holocaust.

His eyes were openly bold in its razor-sharp, onyx, gleam, which was visually equal to the inner danger of his sadistic ugliness he emotionally is vandalized with. I wish I haven't heard the gross offenses he influence into great massacre, I'm sure would be as singeing as the searing seconds my soul felt in the storied fire, he, dehumanized, with heartless arson.

I remained tightly chaired in scared disgust to every recital he told; he seemed appealed by a agenda to show his most vicious thug to the person he thought he'll impress, with his uncalled for damages against innocent people. I remained all to phony in my grins that approved his actions as cool, which I needed to hoax him with, so I wouldn't become his next, million or so, victim, whom would be without the headless body part that would be casually buried in a over flowed, skeleton, ditch. In my position the many mixed feelings that whirled within my stomach, arouse with brave ideas that saw me challenging this monstrous fiend.

My agenda wasn't far from different in its dismay, I was going to express, where, one death is equal to an entire world that dies, like the saving of one soul that is like saving an entire world. If anything, I was powered and severely validated by his chilling stories, through my wicked association with this human vandal.

I was grieved with a madden ire, that was as abominably, god-for-saken, in its mere utterance, I would have greatly troubled upon this, once, good earth. The smallest irritation that blazingly dreaded my awful duress, had its horrific origin, strange, with a closed door evil, a demonize source has creatively ruined upon the vex essence of my major disturbance.

My fury was unforgivingly violent in its natural state, that the four legged lives, in the animal kingdom, dependently insist on.

The inconceivable nature of my, world-court, menace is as atrocious as the unimaginable behavior of vicious dictators, whom accomplish a million deaths in their thoroughly, blood, ghastly rule.

The deepest worst of this sporadic intensity, doomed and deliriously dramatic, in its favor toward dis-ease, seems more heinously consistent in its sudden abuse, unknowingly placed within my demented temple, spontaneously. Its like I would be positively sense, in one angelic

moment, then amazingly become the dour enormity that possessed, an innumerable impassioned clan, that fulfills over a thousand or more massacres, against a expansively dead human kind.

 This internalized inferno was so consuming in its ever bubbling, torrential, mistake, I too would have been grievously devoured by, into the butchered condition of this personal blasphemy, which could' ve kill my life directly into the fired-up origin, that completes my troubling heart and mind with its truly wicked sense, I satanically would come to know in the smoldering underground, this haunting reality vividly dismays.

 Waist thin, shrunk in my ever moving exercise, in search for the demise of my teenage peer, which were hours upon hours, me, working in my furtive espionage for this assailant, I wish to experience the doom, that I felt in its entirely, which infested my heart with sicken germ. Painstakingly in my terrorists search, my walk was bitterly confined to each avenue and block, scoping for a life, I would have definitely consumed, in the life ending onslaught of whirling bullets, who's speed inescapable, combined with the hateful might in each squeezing force, that is my directive palm, locked in its furiousness, who's touchy-feely thoughts were torrent in its forwardness to kill. Mercy at this time didn't come into the virtue of this stolen heart that always eventually forgives, instead I was lost in my revenge's lust, with intentions to spill blood, in the name of my falling, eleven-year-old, fellow.

 This wicked dunce was so heavy on my assumed to be quited mind, that had in my temple's reflection, thoughts, Angels are afraid of. If this stellar Hierarchy choose to know what I was thinking, then this starry grace would have banish me into this scorching inferno, drowning me within the stratus core of this volcanic singe, that would permanently boil my soul in this eternal cesspool, which would consume my feculent degeneracy forever.

 I was hatefully deranged beyond even a serial-killer's explanatory comprehension, that collapse time, through this demonize meditation, me, visualizing the orchestrated chaos I'll conduct in every physical motion I could unload with my six-chamber burner.

 The weaponry I gained that seemed perfectly constructed for the grappling senses, completed my sadistic nature, that was mainly problematic in my balling fist, which gave me my manliness through my quenching hands. The mentally deranged danger of my offended masculinity seemed instigated even more, at each sight of my, handheld firearm, that I passionately caress with my palms and incessantly looking eye-balls.

 What I've held in the clever study of my touch and eyes, revealed a trigger-happy notion in the imaginary exclusion I wanted to point my pistol at. The wide and deep tube of the gun's raw nature, seem holed with a life I could essentially describe as profound in its cause to kill. This revolver seemed so snake in its elongated nozzle, which was of a steal brown, and blacked-finish, its snout spuming bullets from the chest of the strong-arm chamber.

 Its heavily destructive form remained quietly kept in its un-used ingenuity, particularly for massacre, seem to always be silently alive, even in the coolest climate it eventually made hot, by the life ending testament it showed to my blazing intuition. How could a glory of this sort be

legend in the hard trigger of this unholy tool. I've felt the punishment flamingly authored by the evil danger of this hand-held roaster. Indeed, no civility at all is reduce by the presence of this soul stealing thief, which had a handle made of fine wood. Instead of the supposed calm that would retreat one into safety, I felt combatively pushed by the six-chamber brutality I seem compel by, to accomplish a, try-it-out, kill, even in my safe and sound guard I held in my waist.

It was all too sexy in every sinister sense, where this revolver's, classic, seemed antiquely energized with past performances it horribly bore, while in the talent of its murder it knew many times in a gun-fight past. All I could do was marvel at the way it menacingly stood, all too its, wicked expulsion, that cause my observing heart to tremble at the bullet piercing possibilities it slain.

The eyes of my cop and robber boy came alive in the adolescent fascination that showed a bizarre realization of something terrible in this real-life assassination, which is certainly not the toy gun that can only wet with water, compared to the flaming, reality, the, gun's nose, pops, off.

Their seems to be an intrinsic nature with guns, that the male ego, is in love with, in this touchy unification. This connection, between the observing eyes and the sensual intelligence of touch, notoriously elates masculinity, full and capable through a fire-arm power that expels the soul from its physical body. My hunting-man-life was made heinously gold, through every form of the design my steel revolver inspired me with. Its big-daddy, massiveness, was perfect in its chubby dress that made me brimmed with bullet pride. Its mechanism was drawn with a detail construction, that revolved a fast speed which spills, four bullets, at a time, in its second or so rapid-ness.

This mechanical intelligence, is not the only thing to be praised, when scoping into its internal machinery, that must be giving the highest honor in the field of engineering genius. The intricacy of the gun's internal organs was so detailed like a grand father clock, that was as well tuned in its precise timing the navel-observatory is in control of, which clicks and spins with innumerable wheels and devices, that's indeed the ingenious reflection my gun showed. When deeply glimpsing at the outer face of the pistol's completion, the aesthetic wisdom conjured in an artist soul, that gave this gun its vanity, is pleasing to the shallow eyes, where love is gained through the watching senses, that is made, fascinatingly mesmerized, by the form of my cedar-wood shotty.

It was so fierce in its mighty structure, its metallic finish, absolutely pristine in its beautified danger, with a lustful muzzle that ejaculate the tips of yellow and bright-brownish, bullets, into an enemies flesh, has a superficial attractiveness the male heart cannot deny. Its antique gleam was of a bright satin finish, that had a amber-noir collected in its mixed steel hue. In these instances, I had in my fleshy hands, the wicked, but beautiful to man, instrument, that allows for a spirit to enter some eternal light, in this galaxy's starry ethers, where innumerable spirits are fresh in their ascension only through the gates of death.

This gunning pleasure is the same sweet intensity, felt when grasping the hips, buttocks, torso, practically, the entire form of, her, which elicits the same loving chemistry, that furiously pumps through the chaotic heart, in lost to such palpable pleasure, that makes hand drunk in its

own climax. I've discovered a provocative admiration, I never experienced before, that was a jubilee that is exclusive to a man's ego, which some how consummates his masculinity, to his ideal partner in its warrior grace, which is tightly formed through the slinging fingers, in this, never-letting-go, cradle.

Every love must come to an end, and so it did, the day when approach by plain clothe officers, in their investigation about the daily sounds of blasting slugs. My lust developed not only to seek life ending revenge, but also for the audible climax that is felt in each shot that hammered the atmosphere with crashes. Its, boom, was menacing in its larger-then-life confrontation that shatters sound, which somehow made me a man at each power hungry shot. My ego was seriously lost in its cowboy stupidity, where the brandishing of my, life stealing might to girls, hoping to charm them with my, dangerous manliness, easily lead to my capture, because of my public show to the entire world. All through the day and night, that became weeks and months, waiting for this devil, I swore to banish back into hell, was never found, in my man slaughtering wait, to help Jehovah, to defeat this homicidal satan, whom took two souls. While in this patient search, I played with my modern day, cowboy pistol, vertically, on top of my building's roof.

My irate condition was so heinously raw, my sanity seemed stolen for this insanity, that was this ferocious normal in each second of my agitated bitterness, that existed in my perturb retardation. I was so wrong in my unwavering lust for hostility, expressed in every moment of my sadistic angst, that drench my clothes with flaming sweat, which soaked me on fire. I was in ardent search for this opposite, I wished to feed my every brutal sick, that removed my innocent soul, for this demonic entity, that crowned me prince of Hades. I became the fiend I vehemently opposed, which was self-destructive in this severely sore excitement that sustained my decaying heart. I was spoiled by this madden will that kept me alive in my world of chilling detest.

The hectic disarray of my avenge was scented with the black magic of stale graves, that are without the decorations of bright lilies and cement angels to make me holy before I enter the house of this HOST after my ugly murder. The courage I possessed was backward in its thirst for everything under the umbrella of this murdering wit, it seems, I only have talent for, in this life I only knew, instigated by this, eat-or-be-eaten, jungle.

Fear it seemed was far from my harden chest that was too strong to receive any form of this wispy goodness, that showed a faith grandeur then theresa's miracles that has kissed a thousand babies with plague, whom then became newborn saints in the palms of a glowing High-priestess.

Death it seemed was not enough to keep my life out of harm's way, even in the stiffen demonstrations of these lifeless forms, a decease that could not offend fear with halter, I embracing my rooted story held forever in the midst of my deepest burial in this worm and insect earth.

My quarrelsome poison existed in each militant demonstration that was envisioned in my livid imagination, that I conjured in every detail of what wrong, I could inflict onto another, in this brain dead awakening. I was persistently feed the violence of this tumultuous nature, in its, tense overload, which wanted me to be deeply steeped in a gross form of rage. This zealous curse

during these times, took possession of my entire existence, that made brazen and silly, my out and about, murderous manner, which was suddenly hampered by authoritative bullies, who ride around in unmarked civilian cars.

The laughing pals of Irish and Italian, were this badge-less pair, whom collared my life, are themselves too, highly established criminals, who's worldly front is seen in impious prayer in catholic pews, who's priest are drunk with worldly fame, that pardons these so called heroes, that are guilty in their mob-style disposition. They cuffed a archangel, who's sword was paste to his pubic belly, before the retaliation that went un-expressed. The entire ordeal of my conviction wasn't based on the slain issue of my long-gone brethren a jurisdiction has no idea of, but a illegal fire-arm conviction that lead to the slammer I'm currently stuck into. The confinement I'm placed in, is a place where I replay the story of my past in this penitentiary reflection.

My protection is this, rest, in this secured isolation, is all too great in its mighty preservation that tames my life, which enshrouds me in this thinking silence about my yore.

His wake held him fresh in his hush and cradle, that was, boxed, by a fancy cedar based coffin. A lingering force that was this easing mystery, hovered over these lamenting hearts, who's emotions was forced to think about this, higher ideal, that is the biblical teachings of Heaven and God, that slightly soften death's tirade, in its finalized anguish mourners visually and mystically felt. The backwardness of this aborted fate through this restful lay that was surrounded by ghostly and elegant flowers, cushioned him into some sleepy demise, which made him seem perfect in his tailored suit, who's caramel texture relaxed the tearful grief of my soul's, every detailed study of this hard, and yet, soft, dolorous tradition.

All I could do, was stare into the enigmatic intensity that was his gentle face and form, who's eloquent hands were curved and stuck to the hips of his sleeping body. He seemed to be given the most precise sartorial attention, fit for a well dress royal monarch that died with grand nobility.

His burial consummated his form, from one worldly existence, to another, into this galactic infinity, made of this, hopeful, space-bound miracle. Prayers were said, while ever falling tears showed the integral emotions to this underground cause. And then, the greatest finale arouse in his entrance into the soil and twig earth. After that, quiet became this other-worldly spell, in which the very atmosphere that was once loud with shouts and tears, was quietly cleansed by some comforting force, that muted every wail from his family, into some reflective ascension.....

Chapter Five

Malone Hills Academy

When I first arrived at, Malone Hills Academy, snow remain plenteous in its untouched litter, richly bound in its vast virginity. The enveloping omnipresence of upstate's snowy coverage, is as awe-struck as the sea filled quality an ocean immensely fulfill in its mammoth lost. Every frail reflection I took in, regarding the colossus spread of nature's frosted expression, seem too little in my meteorologist scope to adore its northern essence, I could only truly understand with the supreme eye that natured every detail of each elegantly complex flake. The unknown newness beginnings surprisingly wonders with novel suspicion, was hypnotically layered with a bright concept that nap me into a pleasurable state, frontier and far-away with dreaminess. I remember myself by the snowy climate I was present in, entering winter's pure model, through the icy tones of Iceland's scenic perception.

I'm always surprise of my imaginary reflections, where as a little boy ever dreaming and idea with extreme what-if possibilities, has traveled beyond my understood years, whom still mystified about my ability to make believe the over-stretch distant and the un-imaginable. The busy condition of the american ideal, overly crowded and hysteric, was oppositely corrected by the icelandic notions of simplicity and silence their people give relaxing effort to. The misplaced reality that struck me elsewhere made me know and feel what its like to come from the very northern parts of Europe, flawlessly crisp and nordic. Malone Hill, mountain and endlessly country, when I first arrived, had no high-rise buildings to delay the ever-long flow of the frosty aura that absolutely embodied its slushy calling. Winter's ivory twinkle that's abundantly decorating in its sleepy secrecy, shelters everything dormant and pleasantly cozy, that seem spirited with a new-born wait, snow, helps incubate, alive, for the entrance of spring; which is currently unfolding at this passage.

My presence seems unbelievably wacky in this shiny day-dream I confusingly flourish in. Its, as if, I'm silently misunderstood by a euphoric high, my feelings can't explain, while vague by the cool morning of this hypnotic realism and illusion, I'm, softly, why and how--with, in this eye-watering fantasy. Its, as if, everything I thought I'd be, and potentially become, never foretold my imagination, the current expedition I truly participate myself as, in the reality of my fate's unpredicted calling, I now, consciously, answer. The cool obscurity of my emotions behavior seems like a, pleasurable, fairytale, lie, that is mix with a culinary charm and barb-wire entrapment my correctional peers, and I, are cartoon to. I'm more mystically prepared with this, unearthly, wonder, that made it, to a, breakfast-table, I never thought I would accomplish in my domestic reality; where the family I couldn't see, complete with a, man, wife, and loving children, is realized by the strangers I'm amongst, which wish the, delicately, easy, sunday-morning, perceptions of my household oriented ideas I realistically belong to.

The emotionally rugged days I've reclusively known, becomes different in the tender inclusion I'm actually apart of, which is environmentally neat and blissfully correct by honest hellos. In the fluffy midst of all the emotional prettiness that attempts to transform my usual aggression into something ballerina and pink slippers, the stern presence of my reflective study that keeps to itself, is this, tight-lip, ever-combative, masculinity that attempts to keep out the jovial kinship of this blazing blithe. By the fiery essence of this sort of natural hardship, I'm full and bloody with throbbing veins, testosterone, makes persistently aggressive. All that I've wanted in my isolated departure from the public I thought I despise, becomes many welcomes that makes me belong during this eloquent feeling that momentarily tames my usual tirade.

Our mouths bully every morsel and crumb we feed our emotions upon, which help to restore some sense of good we never thoroughly experience in the free world, via the sensual aspects of the oral delight that reduces a once terrible past into the pleasurable mastication we love into our belly. The homey flirty-ness of coffee's odor heavily perfumes the hungry gut of my greedy coziness, while in the midst of the tongue lashing mecca of this, early, kitchen-based, aspiration. In the fellowship of this cooking-room's food and tongue faith, it seems my day-dream is mirthfully welcomed by every saute and fried conversation food tames into embracing warmth.

The ever depressed observer scoffs in disbelief at the thirsty expressions of the, who cares who's watching foodie, that takes a moment to passionately scope the pleasantry, that delights the soul with a profound form of mouth watering comfort, which can cause anybody to be annoyed by the creamy woo between human and food, who's adoration becomes too close in its loving gestures to primp and relish the plate their married to.

In this caramelize fairytale bakery, my senses are magnificently sweetened, while I'm eaten into gorging lyrics, this fork and knife gospel, loudly chews into hungry song. Although fortified by this temperate breakfast, I'm still, non-complete with, whom, way too delicate, in her, cooking gestures: a graceful mother cloaked in faux-fur-slippers, and flowery skirt, I hold in the mothering vision of my sunny-side admiration. The breast and womb actuality I wish to see, as my real life mother, is some what recognize in the replacement of the, lady cook, whom offer me a sense of, peace, every time, I, and my peers, retreat to her kitchen, for our meals, during our stay at, Malone Hills Academy.

The current cherry-top issue about pastries and hash-browns, go un-delighted at each withdrawal from the correctional cafe, I wish I could, lounge in, for the rest of my outlaw life, during this present enslavement in New York country. I'm good at every sight of the menu this unknown women gently prepares, for the thirsty audience the lady chef unquestionably adores. The three meals we're served, is accompanied by a smiley face sanctity that re-creates my most precious little child, whom gently safe and innocently pleasant, by a remarkably evasive sacredness, my pure heart, knows, is sheltered by, with an utmost honesty only a great glory can assure.

When I'm un-church by the culinary worship of this enchanting infestation, from both this soft feminism and delicious food, I revert back to my cantankerously lonely calling that is wrongfully fueled and critically brutal in its stubborn ways. Amongst the deeply envious hostility

of my combative loneliness, my isolated inferiority as this friendless, hard-head, loner, is given remorse by the polite gestures of this feminist cause, which is emotionally docile and jubilantly ginger with hypnotic impeccability. She seems my manliness with the hopes I'll never be alone, who'll escort me to my grave, as this long-lasting friend with an un-dieing loyalty, even in my permanent departure someday.

Femininity seems to give a great form of acknowledgment to the well-mannered ego I'm correctly restored into, where the normal masculine of my berserk frustration, becomes forgiving by the cushy theme of such, its okay, tampon tucking personality, that nipples my wails into rosy cool. She's a positive fuel, for whats, not wrong, regarding the atrocious parts of my murderous man, but for the throbbing virtue I seem to stand tall on, in my awesome victory, she gives me, in her simple recognition of who I am. Even as this tyrannical savage whom ugly and stink with bold disrespect, I'm celebrated by the nature she is master of, when she fills me, and my criminal crew with complete valentine.

Please let it be known, that no thorough fulfillment in this frail story, can just this flower-skirt nature, in my lacking description about such mystifying quality this good girl possesses. Her friendly romance is notorious in its grinning shyness, but innocently open with ease, which is a bashful force that dominates me, timid, in our sainted poetry, about grub and camaraderie. The fire I've known both mentally derange and physically, trapped, throughout numerous, boy, prisons, seems resolved by the cordial forgiveness of this large-hearted affection I've silently witness enter our once neglected and dangerous lives, whom softly born again, as this sissy and kind audience.

A blushing darling, lay giggly in its demure acknowledgment of my witnessing lost. These joyfully passive moments are made with a humble subtlety venus instinctively quites with modest pretty. I'm jovially misunderstood by every shy glance this madame smiles me into, which is silently stun in my weird and glad reality, I think, I'm apart of. The dreamy, vagina-based, theme of this panty-waist calling equipts her gown wearing spirit with delicate breast that are calmly cupped, in its piercing ease, I've magically palmed with my dirty hands, which she cleanses in this renewing trance. It isn't a sexual sort intensely penetrating and selfish in my horny desire, but caressingly innocent in its love for this sort of feminism I hold grand in my platonic worship.

I never been thoroughly told about the abundant grace womanhood pacifies, in its dear attempts to honestly welcome me, more, then a new-born, held ecstatically close to every pillowing crest a mother's bosom miraculously gentles. How could she be so good to me, for how my senses were once dementedly spoiled with satanic thoughts that drove my corrupt nature, who's hopes were to reach the horrific arrival of many forms of ill, that I, imaginatively committed against the humanity that emanates from her womb. She seems casually composed as Marie-Odette, in her forgiving calling, all too, accepting, without indifference to the disaster I've try to inflict toward the society her maternity draws into weeping flesh. Although anonymously unnamed in her genteel, I'm faithful in my crush, at every pen of my love-letter, I ascribe this stranger as gloria, while in the midst of her great confusion.

The pink authorship of such fascinating lady, I've adored, in many of my magically slowed interpretations while here, is consistently dazed by a lady's spell, which softly belittles me without my full grown man, whom noticeably boy in my enchanted gaze that a high-heal glory can splendidly mystify with otherworldly attraction.

The chef, who, when she's seen, gives a glitter of hope to our young hearts in her felon filled kitchen, whom persistently motioned, back and forth, that make many, deranged, pessimistic personalities, let go.... And all is sincerely well in the actions of the, simmering, homemade, food, which usually is a, cooked, since morning sauce, that intoxicate these noses with jealousy, that is angry at time, that is between this supper, we anticipate with eating lust during our stay at this northern, juvenile, prison.

Our gourmet senses are subdued by the sweet scents and brewing smells that break through our, putrid, outlaw, jungle, we linger in, while in our criminally casual moments in Malone's maximum restriction. Food is the only request our attention is atracted to in our looking forward to study, at every pleasurable meal we analyze with soul-food elation. Food is an unseen defense against our always fighting ways, while marred by our hot-headed adolescence, which is quelled by the sensitivity of our sensual cravings, for what is to come each, morning, lunch and dinner.

When we actualize our appreciation for her tongue and stomach treats, a doting mother watches every joyous consumption of our, fat-boy, actions. She usually rest in a quaint kitchen full and scattered with tools and ingredients, where she remains unspoken as a savior that sees the good we are in our earnest fellowship, only a feminine ability can remarkably foster in this intense wellness.

Me and my peers constantly die, and are born again, in which we figuratively are cycle to, with absurd frustration, when this madame comes and goes without goodbye.

The organic delicacy of her nature's, quick-beauty, is sudden in its picture-perfect deformity, which seems like a human expression of a dear daffodil of only, one-week, I've shortly saw. It was as much its spry grace in the un-vain spring that blooms quickly in its fancy, that seems to have perfectly died, as fast as its new-born cuteness, I've glimpse at, which seem marvelously eden. This secret garden I can't thoroughly recall due to its supreme origin my mortality can't enter, is reflected in the earthy twinkle of this periodically stayed holiness in this particular feminist. The natural law of true beauty it seems, must expire early in its delicate force: true perfection is wondrously fleeting in its magnificent maximum, its dainty fragility nurtured upon its purity, which turns into a quickly spoiled demise that will be elegantly born again.

The time I've spent here remains laced with the emotions of my bitter past and the sweet anticipation of my leave. Its at this pinnacle detention which is fully kept and freeing in its theme, my turbulent awareness is felt by. Although this is my last placement, I seem still critically compelled with the malcontent mentality my life hate itself on, which is a terrible form of cruel survival that dominates the aspect of my leaving good.

The wince I've quietly known myself into, silence me with a terrible disparity that only sees the many forms of my living hell, which I intentionally embrace at this dominating point I can't

avoid. A truly sane person can't possibly like the defense of this guarded trouble that holds man thoroughly contempt without his free-will. No Philosophical guardian as Ssaint-jems could disorganize the confined disarray the individual feels in this introverted chaos, which is a silent type that seems perfectly subtle in its emotionally awkward display in the sensitive psyche that seems to control every part of my existence. If my temple is battered then the every day actions of my life will be demented in its destructive disaster.

During this very, slow, lock-down, tragedy, my reality rest on a flimsy cradle that lingers loosely on the whim of my beaten emotions, a tear shedding delicacy that can fall into a darken burrow which can claim my spooked life for good. I'm pushed by the tease of some masked understanding that perplexes my screwy mind with a eery desire in this self-absorbed exploration, which openly hates everything that keeps me away from my freedom.

Its this terrible mentality I've heard is given to prisoners, whom supposedly learns of more corrupt forms of criminality through a cell-block roommate, but the misinterpreted excuse of this crime prone argument, really comes from the absurd ability of the mind's eye that visions only the wrong it can commit again while I stare at this sinister cement-block inspiration. Certainly a thoroughly contain punishment is served, all too previously telling in my emotionally hard notes, but the part that I assumed would be absolved, still remains as cruel as the crime an offender inflicted in the civilized world. I'm still thought with trouble toward my fellow man, but on a more intellectually menacing level to quietly terrorize a person's life. Possibly the immediate moments of my irate disturbance is false in its true definition of how I really feel about this disappointed subject. All I know is that no warmth of the smallest good I could feel within my consistently troubled heart and mind has made it pass the tall and solid towers of this fortified institution, which is figuratively and emotionally unrealized with negativity I still harbor in my heart.

The thickened glaze of this puzzle conjures a supernaturally absurd excitement in this secluded meditation that has only touch the veil that clothes my sanity with sneaky lost in this balefully awed placement. In my detached nurture spiked with elusive barbs and discreet razors that seem to play with a sharp penetration on my bludgeon psychology, with harm too subtle to catch with even my strongest sense, when I'm in wake with reality, where I know the details of my name and life; in which an outer world is not fit for me to normally dwell in, due to my unsaved, long-term, headache. I feel suppress beyond the block and cage instances lifers are kept in, all twenty-four hours of their death-row lives.

The muted foul I'm faithfully dealt in, happens itself without the mercy miracles un-prove in their savior to the most abject danger a soul can be disastrously troubled with. How could my former life, all too precious and innocently joyed in my dear child, be terribly besmirched by the wispy fire that consumes my emotions with a deeply tearful anguish. I'm harm by every answer imaginable in the flaming misery the world has understood in massacre form, dictators, murderously impose. A hurt outside of me, blood and open on skin isn't as dementedly grotesque as the intensity that menaces my heart mute and scary in my death-sentence reflection, about my dieing self, which notoriously grieves me. I wish I knew one favor from a brethren I could call on to show to my subtle wits, the smallest gesture of forgiveness that could smile me as an accepted friend. The out-cast I'm well understood as, belittles me all too lonely with the utmost

separation this sour withdrawal has un-love me into, without even a smiley welcome from the supposedly most buddhist in man-kind.

Love seems to be the issue I'm not into, where no kissy-sissy decency that could adore me belonged and sane, un-attempts me within the tragic romance I have with affliction. I see all the gestures a love-story springs in each expression, I glimpse at, outside these thick windows, which I don't belong to in my un-socially foul segregation. All I need is some company innocently mutual in a togetherness that shows no harmful intent to see my demise, behind bars, which a greater society can guarantee in its safe and sound comfort.

Although I seem well thought in my constant ability, all too vocal with the inner smarts of my analysis of the world I'm in, I feel myself dumb and nerd, with a terrible form of exclusion that keeps me isolated in my company-less separation. The thoroughly versed thoughts I sense in my brilliantly doomed spirit, would possibly be programed better in my person to person conversation I would give to the company that could complete my presence with communicative acknowledgment. I have no loneliness with the mind and psyche, I consistently partner my imagination into, but lack the human relationship that a separate person, other then the personalities my imagination characters by itself.

In the correctional university of this penitentiary calling, which is a public indeed piled and stacked in its fellowship, but I'm not criminally wicked enough to join the worst crimes my peers committed, which got them here. Even in my deeply engage assassination to dispel a soul into oblivion isn't enough for the lost kind that cannot think up the disaster I've try to erupt with thinking will and subtle might. I belong in another category of criminality, which is made of the good, while in truth demented at the tips of schizophrenic plotting in attempted murder secret. I do belong, just not a talkative sort lipped and tongue, but similar in the faces I read that are all too telling of the cruelty, exclusion can exclaim in its worrisome grimace. I too empathic in my suffering as same and subtracted in our shared feelings about such, left for dead sensation, but I'm still unresolved by the emotionally needy ilk that still doesn't make things better in my, poor, self-disrespect.

A student wise through observation regarding the matters and lessons of life would know a suffering that doesn't go complaintive alone, is bettered by the similarly, hurt, company, that shares its infliction. Although one hurt seems more ideal, rather then two wrongs, but the unity of bad troubles, goods, those whom are ill in their collective worries. Its like the hurt the self believes to be its own, is bettered by the idea others are suffering like you are. But this collection amongst the badly beaten emotional society that are labeled as out-cast, cannot give me a sense, a positive well-being flourishes in, as the clear and cool time of spring, where only freedom can truly help caress the soul with liberated ease. I'm denied the social consciousness I could be aware of in my public study.

It seems in order for me to achieve the, always, open-air, aspirations, of the crisp out-doors, I replay the nurturing classics my feelings joyously backs into, full and honest with the parental behaviors that held a child grand and sacred. The intense realism of this worlds' strange protest to its occupants forces me inward in search of the chivalry I felt by my parental buddies that promised to give me the worlds' excellence, even if it didn't have none to part. If I could be a

child again in my spoiled and pure youth, I would be perfectly confronted with the glorious routine of gifts and tender, all for the purpose to see me smile before the man and women that once held me as a cell in their loins.

My noteworthy attitude is good in its deepest formation in the reflective breast of my brimming temple but lack the outer world structure that forms the gathering of this liberated society I'm chained out of. The undeveloped mouths whom lack conversation to anything else but to their thinking selves, possibly are as wise as the ever interpreting understanding I give about the bar-wire tragedy I story in my silently inquiring senses. Once in my unlearned past, I thought it wise to keep the self isolated, where I believed it supremely best to ignore the self away from the collective participation society mainstreams, but it seems the many facets of socialism is a need my existence requires to stay alive.

In my deep dismay a contradiction shows itself in my excluded revelation that is comforted in the loneliness of my individualism which keeps to itself. I know the much better sort of myself in its alone safety, which is my personal space that is more stable then the public part of me: if I'm crazy then let my psycho be alone in its mental trouble, which I would like, to only observe and amazingly see, with, he's crazy disbelief. When I'm by myself, my feelings are certainly deformed but that emotional decay is only looked at by me, where as the watchful society I'm openly amongst see's the distraught defecation my heart and soul is ruin with. Its like I want to be bad all by myself rather then having to be exposed to the criticisms of the judgmental world that critiques my personal problems. When my personality is savagely swollen with a ill form of corruption in this complete sad, then my teary eyed days should be alone and emotionally solitary in its selfish torment. The bipolar, basket-case, silliness I possessively am, cannot thoroughly be bettered by an outside world, in which its only through the self that can aid such inner disturbance.

The chaotic complexity of this inversion that intoxicate my lungs with this tainted introspection makes me feel, as if, I've arrived at something upset and freeing in this absent folly, that are dense ideas, thoroughly clothe in a weird meaning that is placed on the very tip of my bright head, which I cannot give light to, in this correctional inertia that keeps this hacking revelation in a depressingly slow expression. Their are heavy and light cryptical patterns that play on the almighty of my stilled and quick vision, which is a close awareness too much for my existence to hold in this uncured placement.

The stage of my finishing destiny in this period of my tightly-celled life is a aggravating speck compared to the many hassling paths I still must go through, which is filled with favoritism for the wrong rather then the good I wish comfort my ailing personality in these positive circumstances yet to unfold. I wish the spirited tallness of my stellar sight could show me the challenges in wait to infest my life with pain, so I could dodge the bombardment of this ever challenging cause which compels me to detach my head with a rusty pick at each lesson learning confrontation.

When I'm quieted onto myself, I relentlessly, in my own psycho-therapist attempts, try to re-discovery my noblest self, while in my lonesome aid to make me sane. I try desperately to intelligibly construct my situations meaning in this world and the life after it, in this blinkered

imagination: these mental fogs are so thick and spiraling in its hazardously soft twirl, which intellectually survive in its untouched elevated abstraction. The intentionally confuse purpose of this thought-based apprehension that spins in my absent-minded dome with some long-term cause to keep me illiterately hazy in this threshold in wait for new worlds, where I can only enter through these, imperceptibly, woozy, vapor-like, lessons. This mind-stuff ordeal is very zonked and spaced out in its stormy mis-education that crowns me fantastically dunce for now.

The divine veil of this, other wise, mentally perfect gift, that derives from this artistic bank, is frustratingly unearth in my imperfect man that is made purposely incorrect. The brilliant but too intense supreme tonic of this mind-eye blinding glow, are imaginably path with perfectly broken tunnels, for which my escape into the many forms of satisfaction my thirsty soul needs to be relax by. My some-what, gain, and some-what, lost, perception about this, advance, other-worldly galaxy, I attempt to learn, are conscientious grasps of who I truly am, and the meaning of this world, that comes descriptively alive in the form of the angelic quality of the female cook, and in the comforting form of a character whom, gingerly, grandpa, in his antique comfort.

The elderly fellow, whom parents us, in his very aged, eighty-year-old, seniority, is so compassionately mysterious, in his forgiving embrace of the youths in this merciless prison.

Every assailant that is new to this home, he investigates with a caring eagerness, to get to know, these lost, but, who are now, found, children. His eyes dance carefully backward into an investigatory claim of the adolescent subject he cautiously dreams about, while held in the mindful notice of his tactful response. He's considerately noble in his diplomatic ideas, choosing to ignore the ugliness of our deeply troubling issues, due to the elderly quest he's rationally suppose to, at this darling stage of life, where clemency and compassion is easily implored at this golden point.

A noticeably careful grand-mother I knew as, Dulia Noel, learned me of this tolerant possibility seniors exhume from the wise development that has been inwardly spun over time, into such considerate wisdom of this open-heart kind, this helpful and just, pity, humane. A free-thinking spiritual easily gospel by the lenient tongue of this, ninety-seven, year old, madame, chose to see the excellence in me over my obvious mis-corrections; and this positive conviction seems to have increase the parts of my best man to seek the good in my actions, rather then the sinister parts of my doom she forgave.

It seems love yields more of it, by way of its initiation grandpa Leroy emotions for our terribly flawed society.

Although talked and collective in his ever socializing participation with all whom present in this dungeon, his demeanor is quietly kept as this prestigiously wise gentlemen, whom seem engorge with the reflective moments of his classic past and the future he reclines in, with a smooth contemplation. The lax seniority of his meditative force could be describe as a baby-smooth tone, hypnotically piano with a very low pitch of pleasance and enchanting sleep. If in life we've experience this still and cozy epiphany at its most, sub-consciously, hidden, encounter, where we sense a new-age belief about the divine or very thrilling evolutionary discovery

humanity will benefit from, its leroy whom authored this great mystical boon that falls on top our stellar heads that is close in its splendid supremacy.

 A baffling lord whom good and precious as the actions I've describe both emotional and physically performed in his refined mystery, is named out loud by the boys he adopted as worthy and astonishing in his mere acknowledgment for our otherwise neglected ilk. These believe to be condemned patrons I scroll amongst as my, stranger-brethren, utters the famous words of the author of this, fellowship, grandpa, Leroy, alrights, with care-for satisfaction as our affectionately answering guardian.

 A close esteem elevated at the zenith where miracles descend from, is unruly to my precise inquiry of his revelations he knows very much about, in his proximity to the high grace he'll be mounted into, in his near departure within, the un-mistaken hollows without an iota of corruption in its spirit filled paradise. This zen state without the worldly form of a un-rational man, seems to capture leroy with this great perfume I could only smell with the occult senses that is spell with glimpses of this miraculous nirvana. He seems to be the delegate for this space-bound harmony that uses this eighty-year old historian to forgive us for our sins.

 On the stately day I carry myself on, by way of the encouraging and bewildered vibe of this departures bittersweet attitude, a altruistic philanthropist quells me with the form of correction I always sought since I was pushed out a womb, and during the days of my life that felt lost without romance from the most benevolent in humanity.love spills a richness that is inspired from the unseen ego that makes humans bless in their hidden valor they choose to reveal. And here it magnificently is, passionately expose as an angelic form of holiness in its human worship that is joyed with sadness as I leave. I thought myself nobody in this complete burial, a character very quiet and disappeared with un-acknowledgment. As my living death is surprise with the actions of cherish and mourning charity, I too am stolen into a tender force I can't withstand in my masculine attempts to be this young-adult whom must show tears at this affectionate recital. I cry too, magically mixed with sissy and amazement at this love I never knew existed beyond the motherly nature that is forever remarkably bliss in its absolute concern.

 The fraternal expressions in its wettest glide consistently drips suspended at the prelude of my extinction from New York's big-sky imprisonment. What is it that makes him care so much that introduces me with tears at my final hours. A fraternal chivalry softly slaves us angelic and heavenly at this cross-road, I'll leap into, as this little boy he can't help but to amazingly dad in my moving-on detachment.

 A dripping glory spills unnamed accountants of his emotional foster-care he's giving, in my stay at Malone Hills Academy. An unseen senior saw me as this need-be protective child he expresses at each tear-drop filled with virtue and remembrance of my just-born moment that entered this highest, juvenile, detention he humanely wardens.

 This is a ceremony I never thought would happen, especially in the hard filled aura of this cell-block place that must by, a destructive and hazardous nature, be driven by abject forms of cruel. And here it mystifyingly is, the very fairy glances in each gasping-weep sheds something strangely beautiful in its, man, turn, girl, expression he's weak enough to cry out.

His nostalgic resemblance to my long-gone past has appeared emotionally the same as the parental guardian strong-arm and courageously fierce with motivation for his beloved son. Although a slight difference of my true father, a thoroughly consistent cared for concern is emotionally permanent in its nurturing survival that isn't glimpse and gone like my childish yesteryear, regarding the absence of my father's, next-to-never-there, period, during my small youth. As my innocuous boy attempted to see past the grown-up veil of adult marvel, I wondered what he was thinking, as I now, currently saw in my adolescent continual regarding the personally quiet to himself, which are actions that mimics my fathering past in the duration of my lock-up presence. Leroy continues the onset journey from the point of my dear child, which has now come forth in this wondrous day-dream where the pieces of my life-time are played out of sync: what was parentally then, was left off for the current episode I'm darling to with absolute honor. This is how in tune the wisdom of this character I knew as wise as the moment I believed him guardian of this lost-boy world.

There were no problem days empty of suffering, for which I saw each time he surrendered to himself in casual thinking full of abstract contemplation. I felt sorry for him at times, as the smothering wings of this archangel remained un-theme to what it mystically has to do, for which the un-spoiling goodness of grandpas calling went undone with love for this juvenile university: it was as if a good so sharp went dull during the moments where no care was required, which made him lack the nature he seem to live for every second of his humanitarian life. If no good was done by conversation to fulfill his task of sweetheart fellowship to all whom neglected, old-man leroy would go dead when without any form of admiration, he by some divine calling, must fulfill this harsh world with.

It seems I must be dieing a good death for what is normally told during the extincting form of massacre that obliterates a soul into a spiritual thinking which flashes the episodes of the dieing's lifetime; instead I see all that is related to good during this remarkable sleep and wake insight that slows the time of mortality with the cosmic force of eternal powers which possess the atmosphere where our souls now are magically stilled.

The pure form of care does this to any worldly environment not use to the miraculous function infinitely sky-bound and cosmo, which I've found in the deep understanding love has presented in its teaching virtue that provides a sharp contrast between the days of my good and evil: the heart part is more cosmically schooling in its awestruck nature. As my highest point blissful and miraculously sorry, up to the enigmatic ceiling of this out-the-box temple, where a evasively wise broken crown makes me philosopher-prince with un-harmonious truth.

The weird troubles of my good seem to gather many wrongs to teach me with a corrective insight for the sake of the spiritual place my soul will re-unite in, with the education of the mortal world, a ruler of this starry-space will want to learn. The misinterpretations of life is the best interpretation that re-establishes a good in backward form, which makes mystic sense through the ironic mechanism that presides over the sullen part of morality's flaw based existence, where its existential rottenness that is non-god has to start backward to go forward to reach a place of peace.

This is how far up the adulated friendship of my masculine author during my past has come to surprise me with devotion. Its euphorically shocking how the cliff-hanging past of my rosy youth has climbed its cosmic way into the correctional odyssey that stands in the fond revelation of this parental reappearance. A masculine girlie-ness from within me, comes up as, a strong silent type in expressionless thinking that attempts to hide the affectionate disability of this heart broken problem demonstrated in the evolve personality that doesn't care if it shows the details of feminisms eye spilling theme, through his boot and jean make-up. Crosby the great is old enough to call up the expressions of remorse he could never be un-manned by, although thoroughly girlie with the soft-girl habit of cry and tissue. This baffling form of goodness is so mirthfully evasive in its hurtful silence and care-ness, where the strong and melted feelings I'm presently aware of, are joined by the rotten life-lessons I've conquered by the dear expression of this acknowledgment that tells me I won.

Although he is not sacredly book by a special bound knowledge, he provides another sophisticated sort compassionately divine, and as fantasy, as the glorious waterfall he pictures with his eyes.

I'm sorry too in the teary eyed form I'm suppressed into at the last of my unfolding hours, that try not to shed the inner belief of my obviously torn soul which comes alive in my beading tears. As he stars, I twinkle with desperate emotion as this cleansing savage lovingly fortified in my renewal by his omniscient grace.

My toughness is warmly cracked and heartily timid as this weak young-man, whom, now, too raptured with a sharp sensitivity that internally dominates me light and emotionally effected by leroy's, take-care, bawling ... A strangely pleasing and remarkably hard form of goodbye is said, as a very illustrative version of this bittersweet essence I'm fully shown at this exit.... I leave....

I cannot brilliantly call anything up at this butterfly point, due to my ecstatic release. I'm magnificently sense and unbelievably drunk by the unsecured arrival of this new-age enigma that is my discharge. I seem jubilantly hurt as the new-born type once womb and adored by a feminine cave that coddle my growth into real life, where I'm all too similar in my frail bravery to fully adopt my novel individualism--out, this prison.

Although openly okay I'm euphorically disconnected with a vague happening that rises me, more, beyond the, disclose, imaginary instances I thought I'll experience at the moments of my welcome by upstate's grandeur. I'm triumphantly courage upon a larger then my life amazement that, New York's, upper, country expansively spreads in its pleasantly bold and limitless land-themed force. I haven't been national in my, far-away, from-home, expedition, but close to the journeyed possibility I feel in my transient presence full of oak-top shapes and rock filled rivers a dear colorado beholds. While I effortlessly linger in the open-air ideal that waited for me, I reintroduce myself as this casual drifter upon the pastures of montana's mountainous esteem I'm abundantly stretched and tall as, while in the expansive midst of this immense Africa and Russia combined.

The minuscule inferiority of my physical dimensions seems to have grown-out the fleshy habit that was imprison and stayed in its restrictive mortality, which is titanically transformed into the immeasurable galaxy of this free-spirited airiness.

How could humanity mistakenly clouded and supposedly delayed by life's phony troubles, think all is terribly doomed, while in the forgiveness of this, globe, like, betterment, that will keep us sheltered for good, in its ever loose embrace that collects my soul into its worry-less streams.

The peopled society of my entrance is heavily expressive with this obscure force, that seems blissfully confused as this eery release I'm remarkably exposed to, but nebulously not, while caught by the ritual of escape's uninhibited day-dream.

I know the prior conviction of my boxed criminality, but euphorically misunderstand the, what-ever, intentions of the public's blase actions. This trust worthy mystery this society unconstructively plans seems to be my newest study I must re-learn in my, do-it, yourself, self-sufficiency. The highest atmosphere of my break-out expressions are notoriously sky with uncontrollable mass, and instantaneous whims of this lost goodness in each care-free breeze, while in this, summer-land.

'Something' wondrously classic and pleasantly misunderstood blankets me again as the virgin I was during the newborn brand of my pure infancy. I'm serenely indifferent to the wicked past my intense fate slave me to, where the advancement of death's withdrawal from the mortal world into a place of clouds and endless-blue, holy's, me saint and giggly in the novel development of this, un-normal, euphoria.

A million-plus tears dominant and egregiously strife in my prior conviction seems unbelieved at this time compared to the sacred vengeance of my current spell. It seems I'm pardoned and benefitted by the abstract mechanics of a higher purpose. The true worth of my deepest kernel I can't prove alive and spectacular with my worldly eyes, seems to be gathered by a grace far beyond the deceptions of what extraterrestrial books have described. Through the cosmic actions of this supremacy's calling for my adored essence, I feel as if remarkably authored with a million-plus epiphanies in this sentimental orgasm.

In the melodicly strange but yet positive feeling of my hovering and looping intuition, which seems yesteryear in countless lifetimes, ancient and backward, I'm played by every precious origin in this revisiting birth, where a original good is great upon the emotional perception that smoke and mirror my bursting innards with awe and bewitched splendor. I'm quietly jubilant in a gentle form, baffling and courageously enamored at this sudden surprise.

My moments, ago, misfortune, seems to have sharpen the blissful correction of this new-age wonderment, magically galaxy and everything enlightenly successful. I must be sacredly bizarre, as the presence I think I know, which is played by the reflecting ideas of my self-acknowledgement that tells me I'm present, but I feel enchantingly otherwise in a extraordinary attitude that is beyond the mortal concept that is theme flaw and agony. I see myself in the thoughts of my imaginary vision regarding the entire features of my existence but it seems I'm

not the personality and body I've studied throughout my life until the high-ranking point of this secretive wizardry that attempts to reveal 'something' to my spirited suspicion. During this fabulous encounter I'm blissfully womb by freedom, lightly, dressed by a soft tone equal to the delicacy of restful sleep.

A pure love from this master's dominion seems to selfishly glorify me into a supernatural standard that excellency me all powerful. This otherworldly force innocently selfish me as this deeply admired individual where no world besides me exist during this grand embrace. As happily ridiculous is this fantastic riddle directed from a root that is unquestionably proper, my wacky interpretation of this intense joy, feels, death and angelically ritual, with a, ending-cause, instigated not by the usually known, sad, extermination that goes hand and hand into Hell, but through this good irony that is pleasurably sharp and life-stealing in its gently blazing ecstasy which orchestrates this spirited passage. I find that the invisible part of my unknown creation is shown a path that can die blissfully, which is discovered during the un-ordinary episode of this astonishing advancement.

An enchanting perfume from this glory-filled elsewhere questions the deepest parts of me with such divine I'm yet to be introduce to in a complete form of organic sobriety that is spirit based in its solar origin. Its as if my mortal defect, although sanctified at this very rich moment, is too corrupt while negatively intoxicated by this earthy realm far from this superior and galactic ideal. One thing that is elated with the god-giving politeness of truth during the encounter of this faint inducing spectacle, feminism seems to be the closes rumination regarding this unearthly power. A she knowledge, forgiving and emotionally caring seems to lead the way into the bold and soft entrance of this magical surprise.

Feminism seems to be the closes description to this enlightenment I attempt to understand with my childish masculinity. Girl and women, young and ancient is first to everything that is relevant to a deity's calling, which is greatly equal to the current exit of my baptismal ceremony that welcomes me back into the unfasten world; all this seems inspired, constructed and educated by the blessed brand of this sacred womb, Catholicism tells the world to deeply venerate.

In my current finale which seems equal to the infinite ability a universe is effortlessly possessive of, I dwell upon a razor-edge conclusion mysteriously excited by the nebulous pinnacle of this departing championship, schemed by a faithful omniscience whom promised me its un-dieing rescue, for which I've surely received in my beloved immediacy.

I never was abandon by this highest sorcerer, where I only was blinded by the illusional disability of my supposed tragedy's that was intended to sharpen me as Philosopher-prince with wise life-lessons.

Truly, past, in-completes everything non-existent and eventually gone and forgotten. This is why savage tears and emotional trauma today will be thoroughly victimize by time's passing.

If luck has many layers in its wins then I've reached the purity of its most favorite glorification that is publicly world and natural in its airy blessing, which seems to totally

participate me welcomed in my acceptance at each spontaneous ability not to be controlled. Freedom is victorious in its elated dizziness, which is perfectly, un-clear, with liberty.

Chapter Six

Author/Creator of---the Cinematic Book: The Newest Visual Entertainment of Our Time

Seeing Fathering Madame Midnight Beyond the Plain Text Version---Through the Cinematic Book: The Newest Visual Entertainment of Our Time

 The Cinematic Book: is the Newest Visual Entertainment of Our Time---where the Cinematic Effect is what Motion Picture Film is---in Still Motion Picture. Fathering Madame Midnight will be the very first presentation of Films' Motion---in Still Motion Form: It's a Movie in Still Movement. Experience the newst birth of the alphabet in the drama of its new shade. Indulge your senses in the scenery of this entire story, from start to awe-inspiring end, through the light and color that's specifically created for the theme of this story. You'll be amazed at the life like portrayal of Zazah Clemens, Pasadena Jovae, and Phillopian---coming to life, in the 'speaking to you text' and the scene for scene environment of this story beyond the plain text of this book

 You'll be more than WOWED, when viewing the plain text version---Through the Photographic Lens of the Still Motion Picture. This is a Full Length Photographic Animation Which Features: The Motel View that starts this Still Motion Picture; Where Zazah start in the dark; Her Sacred Torso (Statuesque Bust); Midnight ladies, Am Gentlemen, and Always Up Johns; Where Zazah Enters the Light; Another CINEMATIC BOOK preview to come; What's a Still Motion Picture/Cinematic Book; The In/Eternal Root of the (Whole-Womb-Hole); The Red-Germen, John the Vampire---Who Love Her to Death; Phillopian from a Wondrous window, with Pasadena in the Light; Pasadena Jovae the (Womb/Whole) of the all and All; AND MORE . . .

 The Cinematic Book Version of Fathering Madame Midnight will be released in---April 15-2016
 For 1 Day Only, it will be Free.
Please Visit, http://www.stillcinemabook.weebly.com/

ALSO BY SSAINT-JEMS

FATHERING MADAME MIDNIGHT [&/CINEMA BOOK]
FROM FLESH INTO FREEDOM
MY HOMELESS NEW YORK CITY [&/CINEMA BOOK]
NICKY'S AFFLICTION
THE CINEMA BOOK [&/CINEMA BOOK]
THE NEXT GALAXY
THE PRESENT TOWER PHOTO BOOK
THE SPIRITS OF ART
THE UNIVERSE'S MYSTIQUE
VOYAGE INTO HAITI PHOTO BOOK
WHOLE-WOMB-HOLE PHOTO BOOK

http://www.stillcinemabook.weebly.com/

www.ingramcontent.com/pod-product-compliance
Lightning Source LLC
Chambersburg PA
CBHW021456210526
45463CB00002B/795